P9-EDA-657

PICTURING
CALIFORNIA

Picturing California

A CENTURY OF
PHOTOGRAPHIC GENIUS

INTRODUCTORY ESSAY BY
Bill Barich

EDITED, WITH AN AFTERWORD, BY
Therese Heyman

PHOTOGRAPHS FROM THE COLLECTION
OF THE OAKLAND MUSEUM

Chronicle Books
SAN FRANCISCO

THIS BOOK is the catalog for the exhibition *Picturing California: A Century of Photographic Genius,* organized by The Oakland Museum with the generous support of the National Endowment for the Arts and the Florence Burden Foundation.

LIBRARY OF CONGRESS CATALOGING-IN-PUBLICATION DATA

Oakland Museum.
Picturing California: a century of photographic genius / introductory essay by Bill Barich; edited, with an afterword, by Therese Heyman; photographs from the collection of The Oakland Museum.
p. cm.
"Published on the occasion of the exhibition California landscape photography from the collection of The Oakland Museum, organized by The Oakland Museum . . . Exhibition itinerary: The Oakland Museum, Oakland, California, August 26–November 5, 1989 [and other locations] — T.p. verso.
Bibliography: p.
Includes index.
ISBN 0-87701-664-x.
ISBN 0-87701-588-0 (pbk.).
1. California — Description and travel — Views. 2. Photography — California — Landscapes — History. I. Heyman, Therese Thau.
II. Title
F862.019 1989
917.94'0022'2 — dc 19 88-62665 CIP

COPY PHOTOGRAPHY
M. Lee Fatherree;
page 72 by Eddy Dyba;
page 94 by Daniel Babior

PRINTED IN JAPAN

THE OAKLAND MUSEUM
Art Department
1000 Oak Street
Oakland, California 94607

CHRONICLE BOOKS
275 Fifth Street
San Francisco, California 94103

Contents

5

Acknowledgments

Preparation for this exhibition began with the building of the collection long before the pictures were hung or the books were printed. Generous donations from Anne Brigman, Oscar Maurer, and Francis Bruguière and their families; Brett Weston's gifts; Ansel Adams' support; and Paul Schuster Taylor's extraordinary gift of the Lange collection have greatly enriched the museum's holdings.

I would like to thank and recognize those colleagues whose interest and support have contributed to the success of this book, in particular Jim Enyeart, Lewis Baltz, and Arthur Ollman, who have discussed the sense of landscape they know so well, and Richard Misrach and Judy Dater, who recounted the adventures of their work in the out-of-doors. Bill Barich has written an appealing and lucid exploration into the California that has been photographed since 1851, and I am grateful to him for this inviting account. Lorna Price brought many aspects of editing to the overall manuscript, also lending an expert viewpoint. Jeffrey Fraenkel, Paul Hertzmann, and Peter Palmquist were informed and helpful in verifying dates and media, and expressed generous interest in the selections. John Bloom, John Coll, and Raymond Wilson provided valuable assistance in locating information on some of the elusive photographers.

I am indebted to the fine staff of The Oakland Museum. From the outset, Chief Curator Christina Orr-Cahall encouraged the broadest view of the project, and Harvey Jones, acting chief curator, continues this support. Katherine Ware's work as exhibition assistant has been essential to the checklist and indispensable throughout. Christine Droll gave freely of her time and proofreading expertise. Copy photography from the original and vintage prints was conscientiously undertaken by Lee Fatherree, whose own feeling for creative work lent added respect to the process of making transparencies.

I have enjoyed working with the staff of Chronicle Books, who have shared their enthusiasm for the pictures and the project.

Most importantly, thanks go to the photographers who have been inspired by California. Their work appears on the following pages.

THERESE HEYMAN
Senior Curator, Prints and Photographs

Acts of Attention

by BILL BARICH

We all remember our first trip to California. It is a place less western than mythic, and the elements of its landscape are firmly fixed in the American mind. Where else is geography so wedded to fantasy? There are palm trees in Florida, it's true, but they seem beside the point, merely incidental, and do not suggest the nearness of movie stars, surfboards, or blond boys sunning in bikinis. The meaning of our position here on the edge of the continent must be that imagination has to turn back in on itself, or be lost forever at sea. I recall driving over Donner Pass, in 1969, on the last leg of a wild escape from New York, and flipping down the top of my Corvair convertible, so that the mountain air could wash over me. How had so much granite come to rest in one spot, and why did it make my heart beat faster? With my eyes, I must have been taking pictures.

"Everything worth photographing is in California," Edward Weston once wrote, sweeping away all the other states with typical decisiveness. He was responding to the diversity of textures around him at Point Lobos, on the Monterey Peninsula. Look what the coastal light could do to a cypress, or to a woman's breast! A streak of pantheism runs through anyone who chooses to live in the midst of such natural beauty, and Weston might have been undone by it, if he hadn't been so disciplined. Up at four or five o'clock every morning, he'd write in his daybook to get the fires going, and then would breakfast on fruits, nuts, and cereal. The only things that stood between him and absolute purity were sex and cigarettes. He never learned to drive, and when he received a grant from the Guggenheim Foundation, in 1937 — the first ever awarded to a photographer — his young lover (later his wife), Charis Wilson, had to chauffeur him around, so he could make good on his proposal to immortalize the West.

The first professional photographers who brought their cameras to California didn't have it so easy. For the most part, they were employed by a government survey team, or by a railroad company, and they soon became accustomed to thinking of westward travel as a great adventure. Following in the wake of the Gold Rush of 1848, they were prepared for the idea of meeting Indians on the trail, but not for the reality. In their journals, you find accounts of stubborn mules, drunken guides, derailed coaches, and nights spent

7

sleeping in the sagebrush. The men developed sore backs, sore butts, sores on their lips from the desert heat, and sores on their hands from reins and ropes. On their packhorses, they carted gear that sometimes weighed more than a thousand pounds, and it included glass plates that could splinter or shatter if an animal stumbled. They ate poorly, except in the cities they passed through, and personal hygiene was not a priority. It took a rugged, nineteenth-century optimism to survive on the road, or at least a naive American desire to see what lay at the end of it.

The work of these photographers was, in the main, documentary. They were hired to make a visual record of natural resources, and of planned routes of transportation, but the landscape was so spectacular that they couldn't resist doing some free-lancing on the side. California was still a frontier, in the process of being settled, and the demand for images of it was high. What the public craved most was a demonstration of the new territory's superior scale and its open spaces — the

insistently wide views that hit a traveler as soon as he or she crossed the Mississippi. Mountain ranges, cataracts, a glittering expanse of sky: in essence, the Big Picture, a precursor of special effects and 70mm film. It's no accident that human beings were often portrayed as a dwarf species, posed in front of redwoods, or on a precipice overlooking a gorge. We like to read a transcendental reverence into such tableaux, but in fact many of the redwoods were eventually toppled, the valleys were paved, and the rivers were dammed. A few pure souls may have been studying the Prime Mover's signature in leaf and glade, but for an average explorer the wilderness was just a new arena for doing business.

A free-lancer seldom had any trouble selling his photos of California. He found an eager audience in the editors of such publications as *Harper's Illustrated* and the *Overland Monthly,* which printed stories about westward expansion and wanted materials that their house artists could turn into engravings. There was also a strong national interest in panoramas — a number of images bound together to reproduce the view along a horizon. (In 1846, before the opening of the West, the most sought-after panorama in the country was a dramatic shot of Cincinnati's skyline.) But the best

customers by far were the firms that distributed views to the owners of stereoscopes. To accommodate the optical technology, a photographer needed a unique stereo camera — it had two lenses set two-and-a-half inches apart — and most men carried one, along with a bedroll, some pots and pans, and the essential tools of the trade, such as an axe.

The axe came in handy for chopping firewood, of course, but a fellow also found it useful when he undertook minor deforestation projects — say, the removal of unsightly twigs and branches that might mar an otherwise elegantly framed composition. Actually, it was common in those days for a photographer to manipulate nature for aesthetic reasons. Carleton Watkins routinely dug up ugly stumps with his spade, but his efforts were nothing compared to those of Eadweard Muybridge, an eccentric Englishman, who was the slickest tactician of the expeditionary era. On location, Muybridge was part acrobat, part Cecil B. deMille. Not only did he climb over slippery boulders and ford raging streams, he sometimes had himself lowered by pulleys to treacherous ledges

where even guides wouldn't go, so that his photos would be startling, impossible to duplicate. In his studio, he fiddled with the look of clouds; in the field, he cut down trees by the score.

It's tempting to accuse Muybridge and the other pioneers of cheating, but it wouldn't be fair. They were just trying to manufacture a sense of wonder that corresponded to their own. Without a human being to act as its filter, a camera can be too cold, too analytical. It might show a Sierra Nevada landscape of riprap, deadwood, and buzzards on the wing — that is, a universe several notches below any ideal. But with some judicious tinkering, a gifted photographer could mask nature's imperfections and create a much grander (and much more marketable) version of the mountains. This version did depend on true geology and botany, but ultimately it had more to do with the feelings of the person behind the lens than with a faithful rendering of reality. In terms of photography, then, we should admit that California has always been something of a fiction, right from the beginning.

O f all the nineteenth-century icons in California, none was worshipped more devoutly than Yosemite Valley. It has become so familiar to us, and maybe so overexposed, that we have difficulty imagining what a virgin territory it used to be,

thick with wildlife and controlled by hostile Indians. The Valley wasn't even described in print until 1855, when James Hutchings, an Englishman like Muybridge, hiked into it with an artist and a friend and wrote a newspaper story about it for the *Mariposa Gazette*. A recycled account of the journey ran later in the first issue of a magazine Hutchings published, *Hutchings' California Journal*. According to its founder, the magazine's purpose was to present readers with tales that were "noble, manly, useful, intellectual, amusing, and refining."

A trail from Coulterville into the Valley was completed in 1856, and a crude hotel went up the following year, but this just made a tiny dent in the terrain and did little to ease the journey from San Francisco. You still had to ride a ferry to Stockton, and then board a stagecoach and rattle along in it for a hundred miles or so, until you reached a pack station, where you mounted a horse and spent about twenty hours covering the last forty miles of pocked and rutted ground. If you were staying at the hotel, you

couldn't expect much in the way of convenience — a decent meal, perhaps, and a bed whose primary virtue was that it kept your body off the floor, safe from scurrying mice — but for the pilgrims who were willing to endure the hardships, the trip seems to have been worth it, and Yosemite soon gave birth to a tradition of overblown writing about nature that persists to this day.

In chronicles of the 1860s, the Valley was always *magnificent, exquisite, picturesque,* and *glorious.* Its lakes were *silvery* and *mirror-like,* its meadows were *vernal,* and the surrounding peaks were *snow-clad.* These adjectives surface over and over again in letters, diaries, and books, usually coupled with such nouns as *temple, cathedral,* and *light,* as if a higher force had put a limit on the potential number of responses. Authors, both amateur and professional, were quick to link religion to the landscape, drawing on the frayed teleological argument that a watch must imply a watchmaker. A visitor, if he or she were properly humble, *had* to be inspired by the sequoias, the waterfalls, and the mountains. The inspiration came not so much from the physical grandeur of the setting as from its atmosphere of antiquity and peace. To travel there was to go back in time, toward a sort of Eden. During the years of discovery, Yosemite served as a focus for our most poetic longings and emotions.

If an expeditionary photographer hoped to earn any money for his work, he had to pay attention to such

nuances, and Carleton Watkins did so very well. A refugee from Oneonta, New York, he traveled west in 1851, at the age of twenty-two, running away from the demands of his family. After working for a while as a clerk in San Francisco, he took a job at the R.H. Vance Premium Gallery in San Jose, doing portraits of brides and babies. Watkins had never operated a camera before, but California was still so fresh and innocent that boldness often counted for more than experience, and he survived his apprenticeship without a significant mishap. Striking out on his own, in 1859, he accepted a commission from John Frémont to take some pictures of Frémont's mining estate in the Mother Lode, and, the next year, he went to Yosemite with a state geological survey team, bringing with him a new piece of equipment that would revolutionize the craft.

One of the major drawbacks of landscape photography was that a photo couldn't be enlarged. It had the exact dimensions of the glass plate it was mirrored upon — in general, not much bigger than twelve by sixteen inches. What Watkins had strapped to a mule was a special camera that could hold plates

up to thirty inches on a side. Known as mammoth plates, they were very heavy, weighing more than four pounds each. The camera, too, was bulky, and it pushed the load Watkins was carrying to almost two thousand pounds. There was nothing at all graceful or sophisticated about working with this gear. When the camera was fully extended, it was at least three feet long, and it resembled the elaborate, vaguely menacing item on a tripod that gave Buster Keaton such a headache in the movies.

From the historical record, we know that Watkins liked being outdoors, and it's a good thing, because a man had to be unflappable to survive a photo shoot in the Sierra. We can imagine him trudging into Yosemite Valley on a summer afternoon, then making his slow way up a primitive trail and establishing his camp. In the morning, after choosing an exciting view, he might clear some seedlings, move a few annoying rocks, and pull out his chemicals and darktent. The darktent was really just a hooded overcoat, and if the weather was hot Watkins would be sweaty and would have to be careful not to drip perspiration onto his plates. He'd probably want to fan his face, but he couldn't, because it would raise some particles of dust — enough to ruin his photo. Once he had gathered

the darktent around him and had shooed away gnats and flies, he'd bathe a plate in collodion (guncotton, alcohol, and ether), no doubt reeling a bit when the fumes hit his brain, and then dip it in silver nitrate and insert it in a plate holder. Then, he might step out to look over the scene again, and if a wind hadn't come up, and the sun wasn't too bright, and no animals were wandering through the frame, he would move the metal square blocking the lens, estimate the exposure, and pop the square back into place.

For weeks, Watkins stayed in the wilderness and repeated this procedure until he'd exposed all his plates. When he returned to San Francisco and made some prints, he caused a sensation. The sheer size of the images, larger than any that had been seen before, hinted at the vastness of Yosemite and drew appreciative crowds. Even now, the pictures have an undeniable power; they seem to hold a measure of the Valley's stillness, its timelessness. And when Watkins began printing on paper treated with albumen instead of sodium chloride, the pictures gained in luster and definition. By 1865, he was successful enough to open a retail shop on

Montgomery Street; he called it The Yosemite Gallery. With monumental photos available, nobody was buying stereoscopic views anymore. At the start of the decade, Watkins had received five dollars for a dozen stereoscopic views; by 1873, the price had dropped to a dollar and a half.

For Watkins, fame was a mixed blessing. His work was pirated in the East, sold in bootleg editions, and the interest he helped to generate attracted lots of competitors to Yosemite. In 1867, Muybridge produced his first major portfolio, and when the Civil War ended, Timothy O'Sullivan and A.J. Russell, who'd been photographing soldiers and battlefields, also drifted to California. Accustomed to harsh conditions, they thrived on campfire life and were soon churning out their own mammoth plate photos. In their occasional writings, you can feel the pure, flesh-and-bone pleasure they took from tramping around in the Sierra. When they weren't working, they swam, fished, hunted, and collected wildflowers. One Fourth of July, Russell hosted a banquet on a snowbank, where his guests drank snowmelt mixed with sugar and lemon, and dined on cold venison, apple butter, bread, and cheese.

While the photographers were busy advancing their technical mastery, James Hutchings was becoming a serious entrepreneur. He went on the lecture circuit in the East, introducing mammoth plates to the carriage trade in Boston. He had acquired a hotel in Yosemite Valley, as well as some other

property, and, in November of 1869, a scraggly, middle-aged Scot asked him for a subsistence job as a handyman, feeding the sows and the turkeys and doing a bit of carpentry. This was John Muir, who had formed a bond with the mountains and couldn't bear to be separated from them. Muir had the cranky, impassioned temperament of a West Coast Thoreau, and for years he would rave about the importance of preserving the area ("the most divinely beautiful of all the mountain chains . . .") until, in 1892, aided by the photographic documents compiled by Watkins and the others, he saw the fulfillment of his dream when Yosemite became a national park.

Americans are dedicated hobbyists, so they fell in love with cameras. They learned that a photo could convey poetic sentiments, and it didn't require any words. Here was democracy in action. To express yourself, you no longer had to bother with a notebook, or a set of watercolors — you just snapped a picture. People liked the gizmo aspect of photography; they were fascinated by the mysterious way an image emerged from a box. After all, a camera was a machine, and anything mechanical was scientific and had to improve one's grasp of reality. A painting, being subjective, couldn't do

this, and by 1880 critics around the country were attacking Albert Bierstadt, the artist, because his vistas in oil were too romantic, too distanced from the photographic "truth." (Bierstadt himself was avidly collecting Watkins' prints.) There were amateur camera clubs in most parts of California, and the members had exhibitions and met frequently to discuss their theories and techniques. The merit of a photo was often judged by how accurately it appeared to represent nature. Like a painting, any worthwhile photographic landscape was supposed to have four basic elements: a foreground, a middleground, a background, and a sky.

When travelers came to the West on holiday, they packed their photographic gear, so that they could certify the literal fact of their arrival, and also shoot some pictures of the scenery that had become familiar to them through the work of the pioneers. In a sense, they were asserting a right of ownership, claiming an imaginative share in a jointly held vision. In 1855, the year of Hutchings' hike, only forty-two tourists stopped at Yosemite; fifty years later, the number had risen to ten thousand. Some hotels near the park had private darkrooms and offered them to patrons, and, in the evenings, experts gave slide shows and answered questions. All around the Valley, there were designated view spots, and hobbyists would migrate from one to another. The men wore suits and hats, and the

women wore high-collared dresses, because a trip to the wilderness was still a grand event deserving a degree of respect.

At the same time, these worshipful buffs were putting themselves in a curious psychological bind. Regardless of a photographer's intent, a camera registers apartness. The minute you photograph a landscape, you declare yourself to be outside it, and you create an object that can be contemplated, admired, or criticized — an artifact of civilization. The notion of being separate from the land would never have occurred to an Indian of the Sierra Nevada, who knew himself to be *inside* Creation, linked to the sun and the moon and the stars. It may be that a new technology always proposes new lines of division; at any rate, a feeling of otherness, no matter how unconscious, must have eventually contributed to the rapid suburban development of California.

As tourists flocked to Yosemite, the men who had made it an icon were growing old and dying, sometimes in painful ways. In 1891, Russell was nearly blind, and Watkins, too, was losing his eyesight. His studio in San Francisco had burned down, and though C.P. Huntington had deeded a ranch to him, in Yolo County, his health continued to decline. He became senile and had to be confined at Napa State Hospital, where he died at the age of eighty-seven. Only Muybridge had a pleasant retirement. He'd suffered through a sensational trial for having murdered his wife's lover in a fit of anger, but after a jury acquitted him, he continued doing motion studies for Leland Stanford and then at the University of Pennsylvania — horses trotting, birds flying, men and deer running. The studies established his credentials as a scientific observer, increased his status as a photographer, and also earned him a decent profit. At the turn of the century, he could be found back home in England, building a model of the Great Lakes in the yard of his house in Kingston-on-Thames.

*T*he myth of California as a promised land had currency throughout Europe in the early 1890s, and those who were seduced by it were sometimes disappointed. For instance, there was Johan Hagemeyer, who left Amsterdam for the Santa Clara Valley in 1911, hoping to cultivate dwarf fruit trees in a state where the weather was obliging. Unfortunately, Hagemeyer wasn't cut out to blaze a trail in the West. A neurotic anarchist, he mistrusted any form of government and was devoted to the music of Bach and Monteverdi. In Santa Clara, he got depressed about American farming and complained that fruit was being manufactured, not grown. "Fruit raising here is a business, not an art," he once told an interviewer from the *Overland Monthly,* much later in his life, after he'd shifted his energies from horticulture to professional photography and had become identified with a loose-knit movement called Pictorialism.

Most Pictorialists were amateurs. They were disenchanted with plain shots of the landscape, and they wanted to elevate photography in the public eye and prove that it had artistic quality. As a group, they were reacting to what they perceived to be a problem in aesthetics. The camera, it seemed, had reversed the old Aristotelian idea that art should imitate nature. By 1888, a person could pick up a Kodak, load it with flexible film, aim it at a pretty tree, and do an excellent job of mimesis. To separate themselves from the masses, the Pictorialists adopted a strategy of embellishment and started producing images that were contrived, literary, allusive, and painterly — images that couldn't be construed as documentary or "real."

For Pictorialists, the photo frame was a canvas, and the look of things was impressionistic, as if somebody had smeared Vaseline over the camera lens.

Actually, the soft effects were often added during the printing process, though at times a photographer would deliberately shoot a scene out of focus. You could also get the required blurriness by stalking about in the rain, the fog, the mist, and the haze. To make sunshine more diffuse, you held a piece of cheesecloth, or a silk stocking, in front of your camera. Light filtering through a curtain was a favorite device, especially if it happened to fall on a mother and her child. A person in a costume, preferably one with many folds, was always popular, and so were fuzzily rendered ethnic stereotypes. In his Pictorialist phase, Arnold Genthe liked to enhance his Chinatown pictures by editing out Caucasians and any street signs in English, while during the same period Edward Curtis occasionally supplied his noble braves with prop loincloths and headdresses.

Even the physical world looks different in the work of Pictorialists — it's not solid anymore. Instead, it seems to float, to have no infrastructure, to be a function of mood, not of geology. If you stepped into such a landscape, your foot might go through the earth, like a bullet through a strip of gauze. The sensibility here is twice as saccharine as anything in Albert Bierstadt, but there were still hundreds of laureates who were willing to sing its praises in the pages of *Camera Craft* magazine, a sort of Pictorialist house organ. For example, Relige L. Rolle:

While others write of dawn and dogwood
 trees
I climb a lonely hill to drink them in
While other souls atone for greed and sin
I find in love, an antidote for these . . .

If anyone were destined from birth to join this group, it had to be Anne Brigman, whose life was as piquant as a fairy tale. Her maternal grandfather went to Hawaii as a missionary, and there, amid the bougainvillea and the trumpet vines, Anne received a classical education, along with a sound introduction to the naked bodies of islanders, both male and female. As a young woman she moved to San Francisco, and in 1894 she married a sea captain, who promptly sailed to sea, leaving her alone with her artistic yearnings. One summer, she journeyed into the Sierra, and, during a thunderstorm, she had a mystical experience. In a shimmery moment of animism, she was able to visualize human forms in the rhythms of trees. Grabbing her camera, she began taking photos, and later said, "The beloved Thing gave me a power and abandon that I could not have had otherwise."

The high church of Pictorialism was the Little Galleries of the Photo-Secession at 291 Fifth Avenue in Manhattan, and when Brigman shyly brought in her exotic pictures, in 1904, Alfred Stieglitz liked them enough to feature a few at a salon. The photographs adhere to the broody, melodramatic formula of the time, but they are valuable to us now because they anticipate the link between sex and nature that is so central to an understanding of California. Brigman's wood nymphs may be posed in such a way as to echo the figures on a Grecian urn, but there is enough blood beating in their veins to make them more sensual than decorative. The at-homeness they seem to feel in the outdoors might well be baffling to a New Yorker. It speaks of open windows and deep breaths, of granola and aerobics, and of the sweetly invigorating Pacific climate that keeps inviting us all to take off our clothes. On the Coast, nudity becomes a sign of health, and sex is a celebration.

A backlash against Pictorialism was probably inevitable. By 1915, Stieglitz and Paul Strand, who were major influences in New York photographic circles, were writing articles critical of the trend, and they found plenty of support among their fellow professionals, eventually including Edward Weston, a Pictorialist on the lam.

Born in Illinois in 1886, Weston was given his first camera when he was a teenager — a Bulls-Eye No. 2. (For a middle-class child of the era, a camera had become an essential possession, like a bicycle or a baseball mitt.) The year he turned twenty, he made a vacation trip to California, succumbed to its charms, and stayed on. To support himself, he worked as a survey photographer for the railroads, then tried his hand as a door-to-door portraitist in Los Angeles, shooting family groups, visiting uncles, dogs, and kids. Mexicans often hired him to do funeral photos of dead infants, but Weston tired of being a drummer, and in 1911 he moved to Tropico — we know it as Glendale — and built himself a small studio with a skylight.

Here, on the edge of the desert, he embarked on a more formal career. Again, he was doing portraits, and they were as sentimental as any around. Maids in frilly Bo Peep gowns plucked roses in the Angeleno haze, or put on silk kimonos and played at Madame Butterfly. The pictures were well received, even in Europe, and Weston won many medals, awards, and citations. He had financial security, and that must have been a comfort, because he and his wife, Flora, had two sons and would add two more by the end of the decade. In an odd coincidence, Johan Hagemeyer, vagabonding around the States after his dwarf tree disaster, turned up in Tropico broke and discouraged, and Weston took him in and paid him a little money to clean the studio and the house. For his part of the bargain, Hagemeyer taught Weston about classical music.

The music might well have contributed to Weston's growing despair. He was a restless man, easily dissatisfied, and he could see how short his photos fell from great art. His portraits seemed trite to him, so in 1919 he dropped his commercial jobs and began experimenting with light and camera angles. He did some stark, Cubistic abstractions, and some industrial landscapes that were similar to those Charles Sheeler was doing at the time. The feel of the new work was earnestly modern. Traveling south, Weston set up a studio in Mexico City, in 1923, and became friendly with such important painters as Rivera and Orozco, who fueled his passion for a visual kind of truth. His images kept getting sharper and sharper, more specific and detailed, as if he were following the advice of his contemporary, William Carlos Williams, the poet, who once said, "No ideas but in things."

In 1929, Weston moved to Carmel, near Point Lobos. His life was in chaos, but his confidence as an artist was high. Divorced and a single parent, he was

always on the brink of economic ruin, but women still flocked to his door, and he couldn't turn them away. With his berets, his ascots, and his flowing scarves, he cut a dashing (if slightly clichéd) figure, and his temperament might have been intolerable if his pictures hadn't been so good. He was discovering patterns in the land, drawing a viewer's eye to the feminine curve of a hill against the flat surface of a bay. His vision was also becoming more microscopic, as he combed the universe for intriguing minutiae — a swatch of bark, say, that had the texture of recently tilled ground. Weston insisted that he was not trying to express himself *through* nature; rather, he wanted to penetrate it and reveal its secrets.

The Pictorialists asked if his photographs were really art. "Who knows or cares?" Weston wrote, in *Camera Craft,* in 1930. For him, art was a "word so abused it is almost obsolete." And, in the same article, he went on to castigate the theories of his former allies. "No photographer can equal emotionally the work of a fine painter," he said. "Nor can the painter begin to equal the photographer *in his particular field.*" The reply to this offensive came in a subsequent issue of the magazine, when a

reviewer took Weston to task. "We will concede Weston's greatness in his field," the reviewer stated solemnly, slowly sticking in the knife. "We consider the field small. We estimate lowly the highest achievement in portraiture of gourds and peppers."

Undaunted, Weston pressed on. His friend Ansel Adams once remarked that he was somebody who didn't like to be dominated. "I think if the Apocalypse suddenly appeared, he'd argue with it," Adams said. The men had met in San Francisco, where Adams lived and had a gallery. Though they differed in their approach to photography, they agreed that it ought not to depend on artifice. Instead, it should be pure, or straight — uncompromising in its treatment of the facts. By 1932, they were part of an informal Bay Area group, f.64, that was named for the small camera aperture that results in sharp images. Along with such associates as Imogen Cunningham and Willard Van Dyke, they held an exhibition in Oakland that year, and the clarity and precision of the work on display established without question that serious photography was on its way to leaving behind the old-fashioned romance of Pictorialism.

A nsel Adams' first camera was a Kodak No. 1 Box Brownie. He got it for his fourteenth birthday, in 1916, and took it along on a family vacation to Yosemite. A stocky, cheerful, affectionate boy, he had already proved himself to be something of a prodigy

on the piano, but he was happiest outdoors. He'd hike around the park and point the Brownie at an approved tourist scene, such as Bridal Veil Falls, worrying about the light, about the branches and the shadows, and then he would press the camera button with a blend of joy and regret that every amateur knows well. A photograph never quite lives up to our expectations. The best one can hope for, as Adams would learn, is an image that distills, is equal to, what you see and feel at the moment — an image Alfred Stieglitz spoke of as the *equivalent.*

Still, this experience was important to Adams, because he discovered a subject that was complex and sublime enough to occupy him for a lifetime. By the summer of 1919, he'd wangled a seasonal job as the custodian of LeConte Memorial Lodge, the Sierra Club's headquarters, on the Valley floor. He wanted everyone to love, cherish, and respect Yosemite as much as he did, so he wasn't always the most tactful employee and he could get bristly if a visitor failed to pay proper homage. Like John Muir, he believed

that he was the park's steward, its special guardian; but later, when he was older, he poked fun at himself for being so restrictive and said he'd become a philosophical humanist, able to separate his own euphoria from the rights of others to gape at, maunder over, and sometimes desecrate the wilderness.

What Adams enjoyed most as a young man was setting off on a camping trip, alone except for a donkey. He got a kick out of the miserable trails, the useless maps, and the warped iron skillet in which he fried his bacon. Anyone who has spent time in the mountains knows the eerie thrill Adams must have felt as he came over a ridge early in the morning — when the earth was still damp and the air smelled of pines — and arrived at a place that seemed to have been reserved just for him. It's as if he approached the act of taking a photograph the way a good trout fisherman approaches a stream, with stealth and cunning. In one kyack of his pack, he stored his food (salt, flour, rice, coffee, dried fruit, bars of chocolate, and a can of Log Cabin syrup), and in the other he kept his utensils, his cameras, and his film. His sleeping bag had almost no padding, and he slept in it without the benefit of an inflatable mattress. A mattress, he once explained, was thought to be effete.

13

To some extent, Adams was repeating the journey of Carleton Watkins and the other pioneers, but he had different problems to solve. Yosemite wasn't a virgin territory anymore. By 1920, there were cars, tour buses, and gift shops in the Valley, and a photographer had to cut through fifty years of platitudes, poetry, and snapshots to find an original vision. For Adams, this meant lots of waiting, sometimes in storms, sometimes in zero-degree weather. He did not crop or retouch his pictures, so he had to get them exactly right. He was *making* rather than recording an image, isolating an indispensable view from the clutter of disposable ones. More than anything, he tried to be accurate. When he shows us a pack train crossing a meadow in winter, the scene is so clear and precise that it burns itself into our memory. We can almost hear the crunch of hoofs in the snow, and the call of the drover as he moves the horses on.

Throughout the 1930s and 1940s, Adams and Weston continued to be at the forefront of landscape photography in the West. They influenced how Californians felt about the mountains and the coast, and they

became, whether they wanted to or not, representative types. Adams was the hearty Boy Scout grown into an adult advertisement for conservation, while Weston was a free-spirited forerunner of the beats and the hippies, carrying on the bohemian tradition in Carmel, where his admirers brought him offerings of shells and peppers to photograph. For both men, nature was an article of faith, and they labored to show it simply, cleanly, and sympathetically. They had intelligence and moral purpose, and this gives their pictures a quality of affirmation, even though human beings are so often missing from the frame.

Where did all the people go? Some critics didn't approve of their absence, most notably the French photojournalist, Henri Cartier-Bresson. The world was falling apart, he said, and Adams and Weston just took photos of rocks. It's true that you find little evidence of a social conscience in their work, and they seem to have been almost unaware of the Depression, or the impending war. Their interest, they might have argued, was in the timeless, the eternal; they were pursuing symmetry and order, not suffering and pain. An attitude like that wouldn't do for Dorothea Lange. She couldn't pass by a scrap of land without registering its political implications. Her tendency was to include, not to exclude. "Bad as it is, the world is potentially full of good

photographs," she once said. "But to be good, photographs must be full of the world."

When Lange arrived in San Francisco, in 1919, she was an ambitious, determined young woman of twenty-three, who soon got kicked out of her rooming house for smoking. Although her experience in photography was limited—she'd worked as an assistant to Arnold Genthe in New York and had taken a seminar with Clarence White, a Pictorialist, at Columbia University—she managed to open a successful portrait studio, on a fashionable block of Sutter Street. She had a taste for elegance, and used to serve her customers afternoon tea from an ornate Russian samovar. In 1920, she married L. Maynard Dixon, a well-known painter and illustrator of western scenes, who was tall, bawdy, charming, and liked to dress in capes and cowboy boots. They made a flamboyant pair. Because Dixon was twenty years older, Lange deferred to him and did what she could to give him a comfortable life. In her opinion, he was a true artist, while she was only a talented dabbler who had a business to run.

At the time, many women in the United States were still conditioned to think in such terms and still made such sacrifices routinely. Women had just been granted the right to vote, and only about a quarter of them had jobs outside the home—they worked primarily as servants, teachers, secretaries, waitresses, and clerks. In all of California, you'd be hard-pressed to find more than a handful of female executives. A woman was expected to live within boundaries, and the boundaries applied to most creative fields, including landscape photography. The wilderness was supposed to be a male preserve, too rough and tumble for the "gentler" sex, and women were often thought to be incapable of wrestling with heavy cameras, or of camping in the Sierra on their own.

But by 1920 a few women had broken through and established themselves as photographers: Anne Brigman, who was a skilled amateur; and Imogen Cunningham, who'd sent fifteen dollars to the International Correspondence School, in Scranton, Pennsylvania, for a 4×5 camera and some instruction booklets. A number of Pictorialists (Laura Adams Armer, Emma Freeman, Florence Kemmler, and Margrethe Mather) were active in California, but it was Dorothea Lange who raised everything to a higher level. When Dixon traveled to the Southwest to revitalize himself and do some sketching, she went along and learned to live out of a knapsack and work quickly,

shooting pictures in the moment instead of composing them at her studio. The rawness, speed, and directness all appealed to her, and so did the freedom of being on the road.

In the early 1930s, Lange was drawn into the streets of San Francisco, into the desperate flow of unemployed men and women. Almost twenty percent of the people in California were on state and county relief programs, and Lange caught their anger and suffering, photographing breadlines, beggars, and strikers on the waterfront. As her commitment to the disadvantaged grew, she became involved with Paul Taylor, a young economics professor, who had long been a defender of the poor. Taylor saw how her images could be put to a political purpose, and he encouraged her when others were urging her to go back to society portraits. For some years, he'd been using photos to document his writing about farm labor, and, in 1934, he arranged for Lange, Imogen Cunningham, and Mary Jeanette Edwards to visit a self-help cooperative he was studying in Oroville, near Sacramento.

This began their collaboration. The following year they decided to get married, and Taylor sorted out the messy details and sent his wife and Dixon to Lake Tahoe, where the divorces could be handled with dispatch. Soon after, he and Lange started doing reports for state relief agencies, and then for the federal Farm Service Administration, touring the country every summer. Lange produced her famous photographs of migrant workers, tar-paper shacks, and dispossessed families with all their belongings strapped to battered pickup trucks. With Taylor, she drove through the Central Valley, over the same route John Steinbeck would take later as he prepared to write *The Grapes of Wrath*. In her pictures, the land frequently has elements of beauty, but the beauty is about to be compromised, exploited, or stripped bare. The land is visible, too, in the portraits she did of farmers — rubbed into their skin and caught beneath their fingernails.

For Lange, the supreme truths were the most basic, and when she went to Manzanar in 1942 to shoot a relocation camp for Japanese Americans, she chose to show a bleak row of shanties, while other visitors looked past them to the mountains.

*T*he newspapers in Los Angeles first acknowledged that the city had a serious problem with smog in September of 1943, when a "daylight dim-out" occurred. Said the *Los Angeles Times*, "Thousands of eyes smarted. Many wept, sneezed, and coughed. Throughout the downtown area and into the foothills fumes spread their irritation." This wasn't the only sign that Southern California was coming of age. By the 1950s, real estate speculators were buying up the orange groves, and paved roads ran everywhere. Little towns in the country began to melt together. You had to have a car, or you couldn't go to the drive-in movies, the drive-in burger joints, or the drive-in churches. When Edward Weston took a postwar spin through Tropico, he found to his dismay that the flowers and the vines had been trimmed from his old studio, and that the building had been turned into a center for processing auto loans.

One afternoon in the early 1940s, Aldous Huxley, the expatriate British author, took a stroll on a deserted beach south of Los Angeles with his guest Thomas Mann, and as the men were talking of Shakespeare they came to a sandy stretch that was littered with condoms, thousands of them. "The scale was American, the figures astronomical," Huxley observed in an essay, and went on to relate how he and Mann had puzzled over how the debris had got there. The answer was delivered momentarily, when they caught wind of a plant discharging untreated sewage into the water. Such incidents were by no means rare, and they were affecting most of Southern California. When tract housing began to consume the San Fernando Valley, displacing ranches and farms, there were sewerless suburbs where effluent cascaded down the street after a rain. Yet in 1950, a big-time contractor such as Louis H. Boyar could break ground on a hundred homes and sell them all before the walls were up.

In no other part of the West did the suburbs establish themselves so rapidly. The earth everywhere was ripped and gouged, and in any subdivision, from dawn until dusk, you heard the whine of trucks and the chugging of bulldozers. The Los Angeles basin was becoming a metropolis, with little boxes strung from Silver Lake to Orange County, and almost every trace of its past, including its topographical history, was being erased. You could study the land, but it wouldn't necessarily inform you of how human beings had lived on it for the last three hundred years.

15

Also, the aesthetic value of trees, hills, and creeks was changing, becoming subordinate to their value in a larger economic scheme. A shady old oak was left standing only if it didn't block a spot where a bungalow was supposed to go. The operative principle in tract housing was instant duplication, an almost photographic uniformity, and this, in turn, made photographers question their approach.

Was it possible to find any beauty in a suburban landscape? Some people didn't think so, and they turned away their cameras, concentrating instead on the unspoiled, unoccupied natural world that had captivated Adams and Weston. But more than a quarter century had gone by since those initial acts of attention, and such photos now seemed anti-modern, a step backward, as romantic in spirit as anything in the Pictorialist canon. We tire of images of rocky coastlines, forest glens, and elfin glades, no matter how perfectly they are framed. The work begins to look important only because it repeats the signatures and gestures of the masters. In fact, we are again perilously close to the sentimental.

There were other methods of dealing with the suburbs, though, that yielded intriguing new pictures. For instance, if a photographer climbed to a hillside overlooking San Fernando Valley and took a shot of the spiraling tracts, he might discover patterns as intricate, and sometimes as lovely, as those that Weston had found on Point Lobos. Viewed in a positive light, a tract can suggest the intellectual coherence of an earthwork; in a negative light, it perversely recalls the shanties at Manzanar. Whatever the case, such a photo is unexpected and robs us of our preconceptions; it isn't about suburbia in any obvious way. The same is true of certain images in color, which substitute a sweep of pastel blues, greens, and golds for any opinions or data about the subject.

And when photographers went higher still, into the air, and snapped pictures of the landscape from a plane, they often revealed an even grander design, more subtlety and shapeliness. Sand dunes rippled and flowed; mountains bunched up, like muscles; rivers had the look of brocade. They were reversing the intense scrutiny of Weston, switching it from microscopic to macroscopic. Carried a step further, the technique presents us with a photo from space, courtesy of NASA Landsat I. At a distance of 570 miles, California seems to flatten out and lose some of its distinctiveness, resembling a map torn from a child's geography book. The planets whirling about us are indeed the new frontier, so it shouldn't surprise us if the old frontier appears to be diminished in importance.

Sometimes, an artist chose to tackle the freeways and the warehouses head-on. Take Ed Ruscha, who rolled west from Oklahoma in the mid-1950s, operating under the influence of James Dean, Jack Kerouac, and fish-finned automobiles. He must have had big dreams, but when he reached Los Angeles, he was confronted by acres of urban funk. Instead of running from it, Ruscha photographed the gas stations and the parking lots, just as an innocent tourist from the sticks might do. His style was deadpan, and his images were cool and neutral. He even published books and panoramas in which concrete and macadam were treated as solemnly as natural wonders. In effect, he was parodying our love of snapshots, joking about the American compulsion to record the particulars of every journey, regardless of how offensive or unappetizing they might be. But there is still a quirky fondness for Los Angeles in Ruscha's work, a wry acceptance of its strangeness. "Superficiality can be profound and funny and worth living for," he said, not long ago. "I mean, everything's ephemeral when you look at it in its proper focus. It just happens more quickly in L.A."

As the uses of the land in California become more diverse, so do our ways of responding to it. The simple act of *using*, rather than respecting, or honoring, pushes us ever farther from our early notions of the West as a place of boundless promise. A new kind of scenery begins to emerge, one that seems to celebrate clutter and tolerate trash, so that a drive along any rural highway in the state combines views of utter splendor with vignettes of environmental woe. The closing down of space is also the closing down of possibility, and we can feel the open, embracing mood of the nineteenth-century swing toward pessimism and irony. It's difficult to find any redeeming aesthetic virtue in an old Chevy up on cinder blocks, even if the car happens to be situated against a lovely backdrop of clouds and buttes, but that's the task Robert Adams set for himself in the 1970s.

A dog skeleton, a vacuum cleaner, TV dinners, a doll, a pie, rolls of carpet: those are some of the discards Adams once saw near Interstate 70, in Colorado, while he was on a shooting trip. He could have filled a garbage bag with the junk and had a cleaner, more refined batch of pictures, but the pictures would have been inherently false. Adams felt that if he moved objects about he'd be making an editorial comment, or worse, a judgment, and he

wanted to avoid it at all costs. As he put it, he hoped to document the form that underlies the apparent chaos, though not at the expense of the surface detail. His art depends on an illusion of artlessness, and on a decidedly western passion for plain statement.

When we look at Adams' photos, we are aware of the bright, almost blinding light — a light meant to reveal the damage along with the glory. The composition of the landscapes may be classical, but by the debris we know ourselves immediately to be in the real West, on the outskirts of towns where a Christian banker might live around the corner from a tattooed drifter with a knife strapped to his thigh. Because the photographs are whole, reflecting the integrity of things as they are, we're offered a chance to understand what we've made of the earth. Always, Adams refuses to be cheap. In his humanistic vision, a plastic flamingo on a lawn doesn't imply that the people who put it there are dim-witted or impervious to their surroundings. The flamingo is just a fact, ordinary and unremarkable, and Adams bears it no malice. If he's trying to prove anything, it's that the land has so far managed

to survive the depredations upon it; its beauty, he believes, is absolutely persistent.

Other photographers of the period are not so sanguine. The landscapes they show us are frequently hostile, and can be cruel in their treatment of the poor. A couple in San Francisco react with outrage when Robert Frank interrupts them to take a picture; the camera is a symbol of all the other city intrusions that deny them a moment's peace. On first glance, the public fishing area in Anthony Hernandez' photograph seems nice enough, especially if we confine our eyes to the water and the trees. But then the thin, hardscrabble quality of the park catches us, and we notice the weeds, the dirt, and the telephone cables. The word "public" acquires a dark, new connotation. There are images, too, of polluted agricultural sloughs and of barbed wire fences; the material may frighten us a little with its hint of terror.

In the face of bad news, people sometimes get the giggles, and there's been plenty of giggling in recent photography from Southern California. The neutral tone of Ed Ruscha has been transformed into an outright merriment over all the kitsch and artifice around. A palm tree isn't just part of a desert ecology anymore; it's a piece of furniture for a stage-set, trucked to L.A. from a farm somewhere, and deposited on the grounds of a Sheraton hotel that's under construction. Wherever

we turn, we're confronted by streaks of neon, shiny chrome, and furry pink panthers. Human beings are no longer a dwarf species. They spoil pictures by casting shadows, and they invent domestic environments (gardens, patios, poolside cabanas) where they can be in control. The world looks as flashy as a video clip on MTV, and it leaves us just as hungry.

We have come full circle, then, from the days when everyone agreed that a landscape consisted of a foreground, a middleground, a background, and a sky. Currently, photographers appear to share only an uncertain attitude toward the future; the fictional versions of California continue to multiply. Under the circumstances, it's logical that a mistrust of photography has set in. Art is supposed to be enduring, but a photo always struggles to transcend its moment in time. "The camera must be the workhorse of another medium," Ruscha has said, adding that he'd never hang his photographs in a gallery. John Baldessari relies on a camera for its speed in processing his ideas, not for its aesthetic capabilities. Where Ansel

Adams was delighted to sell thousands of prints from a single negative, some artists now deal exclusively in one-of-a-kind images — altered, doctored, impossible to reproduce. Each image is a private universe; what this says about our relationship to the real earth is anybody's guess.

Among the younger landscape photographers in California, Richard Misrach may have most in common with the working methods of the pioneers. Misrach is in his late thirties and lives in a warehouse studio, on an industrial block in Emeryville. When he gets ready for a trip to the desert, which has been his primary subject for about fifteen years, he loads his VW van with food and supplies and arranges to stay away from home for three weeks. Misrach believes in simplicity. His camera is an 8 × 10 Dierdorf, and he's happy with sheet film. Sometimes, his son Jake, who's seven, joins him on the road, and he always brings along his German shepherd, Kodak, for companionship and protection. In the desert, he usually doesn't follow a plan; instead, he explores, watches the light, and lets himself be led to discoveries.

Misrach was born in Los Angeles and became involved in photography while he was an undergraduate in psychology, at Berkeley, in the 1970s. He saw a

show of Roger Minick's pictures of the Sacramento River delta, took inspiration from them, and got an inkling of what a photo could do. After a period of study, he decided to shoot the scruffy nightlife on Berkeley's Telegraph Avenue. He was still naive about many techniques, learning on the job, and he was so innocent that sometimes he'd read his light meter, do a quick calculation, and then ask a person to hold a pose for ten seconds. He hoped to compile a gritty, hyper-real document, but through the vagaries of publishing, he wound up with a coffee-table book, *Telegraph Avenue, Three A.M.* Its glossiness dissatisfied him, and he was also troubled by questions about the ethical responsibilities of a photographer toward the people he photographs.

In 1975, Misrach started traveling the deserts of the West, reading Yeats, Blake, Ouspensky, and Castaneda, and experimenting with his camera. Again, he was doing some shooting at night, and in Baja California his inexperience with the flash caused him to take some very overexposed shots of cacti. But this proved to be a welcome accident — Misrach liked the spooky look and kept

"barbecuing" things, cataloging a ghost world of natural objects that bears little resemblance to the sedate, classical images we know from *Arizona Highways*. A bit later, he began working in daylight, and the photos he produced were just as revelatory. A freight train, the Santa Fe, cuts through sagebrush, mesquite, and dust, and its passing fills us with melancholy longing.

In the desert, Misrach has found a complicated, infinitely various environment to photograph, but he keeps his approach to it basic. One camera and one lens — that's all he's ever needed, although now he encourages accidents to happen instead of waiting for them. He enjoys the physical sensation of being outdoors — the sunshine and the hot, dry air — and it pleases him that he's able to find a new angle on his material when he has exhausted all the old ones. In landscape photography, there have always been elements of pursuit and surprise; as Henry Wessel has said, "It's exciting when your eyes get ahead of your brain." Misrach's practice is to concentrate on different aspects of the desert, to render them as ideas and as symbols, dividing them into what he calls cantos: terrain, space, inhabitants, visitors, artifacts, and so on.

Misrach doesn't carry himself pompously, nor does he waste much time wondering about what photography is and what it isn't. He feels that it occupies a position somewhere between high culture and the mass media — a place in which he is comfortable. In many ways, his attitude toward the land

can be seen as quintessentially Californian. The desert becomes a potential deliverer of all the important meanings in life, but human beings are only connected to it by a thread. It's instructive that Misrach's most recent project has been to photograph the instances of environmental abuse that exist in every desolate sector of the West. He has shot the secret hangar where the Enola Gay was stored, some abandoned atomic laboratories, and the pits where dead animals (cattle, sheep, and dogs) are unceremoniously buried. Again, we're confronted by images that remind us how uneasy we are in our stewardship, and how difficult it is to live in paradise.

*I*n Roger Minick's photo, a woman in a brown overcoat stands at an overlook in Yosemite National Park and gazes out at a vista that appears not to have changed in 150 years. The woman isn't especially large or fat, but her body still fills the frame, inverting the standard perspective of the nineteenth century. On her head she wears a souvenir kerchief imprinted with a dime-store picture of the scenery she's so raptly studying. The ironies are multiple, but the one that strikes closest to

home is that we may have finally succeeded in turning nature into something merely decorative. At such a moment, our feelings toward the wilderness — what's left of it — may grow nostalgic. On the evidence of the photographs collected here, we run the risk of slipping over a line that divides use from abuse. There is a poignancy in the image of Judy Dater's hands, seen in the quiet sweep of Death Valley; she appears to be prying open a window that's stuck, so she can climb back inside Creation.

In 1871, Ralph Waldo Emerson traveled from Boston to Yosemite and was introduced to John Muir, who urged him to take some extra time to explore the Valley and soak up its essence. Like any tourist, Emerson marveled at the sights, but he couldn't fit a stint of roughing it into his busy schedule — besides, his friends were worried that he'd catch a cold. Muir was disappointed, but perhaps he should have realized that only a true Westerner stays around long enough to stake a claim. It's a sense of dividend, of wonder, that keeps us rooted in California. Along with Robert Adams, we try to see the landscape whole, aware that the woman in the kerchief will eventually start up her car or her camper and drive away. The land, we agree, will retain its treasures and its secrets. It continues to persist, though none of us is willing to predict for how long.

PICTURING
CALIFORNIA

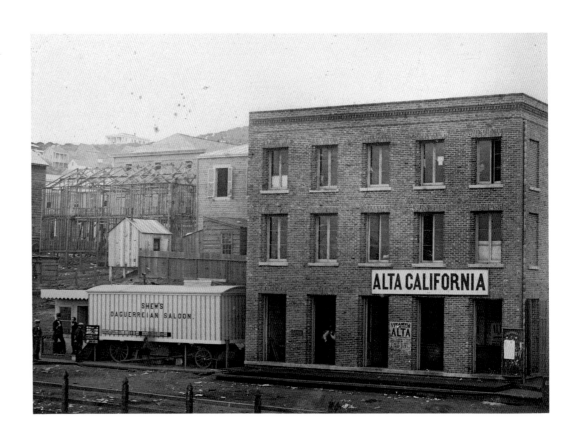

21

William Shew
1820–1903
UNTITLED
1851
Daguerreotype, quarter plate

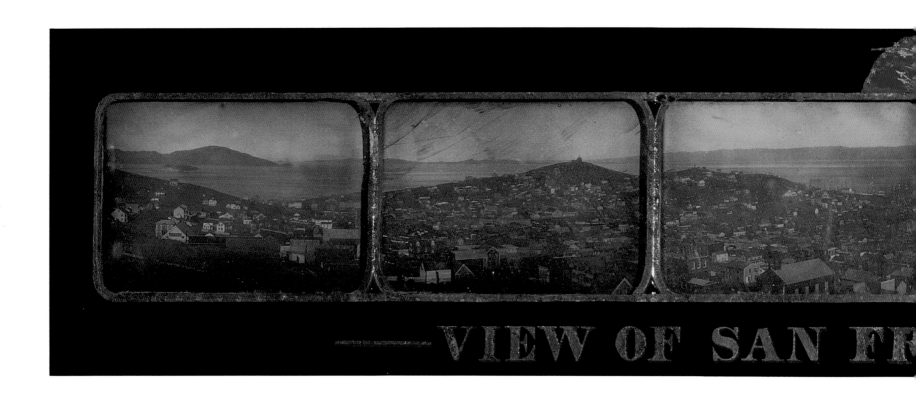

VIEW OF SAN FR

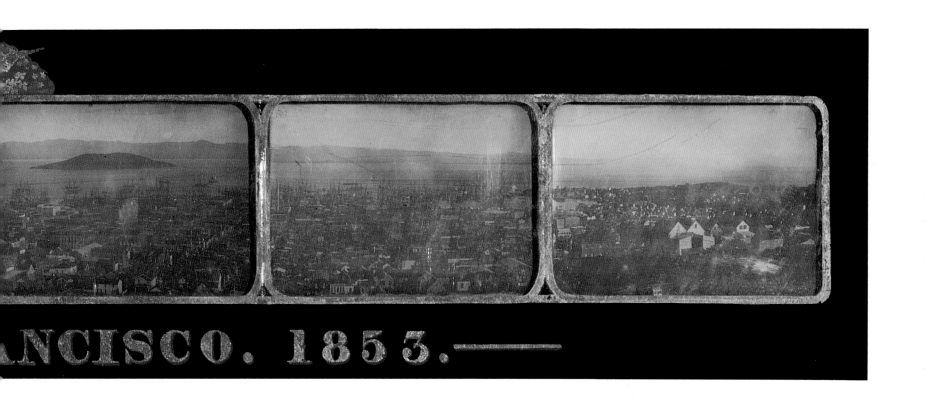

ANCISCO. 1853.——

23

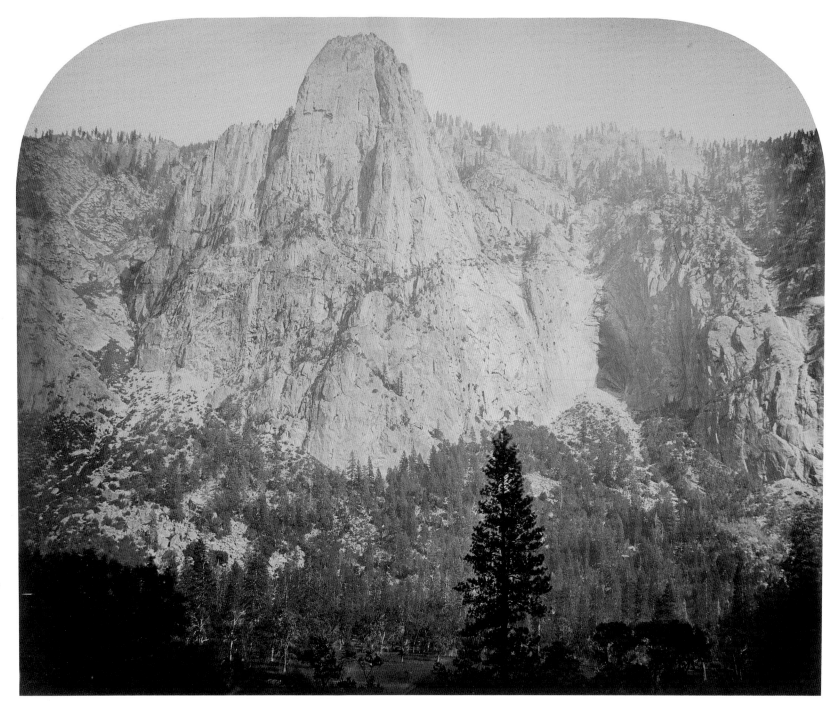

Carleton E. Watkins
1829–1916
SENTINEL ROCK, FRONT VIEW
3270 FEET, YOSEMITE VALLEY
c. 1861
Albumen print, mammoth plate

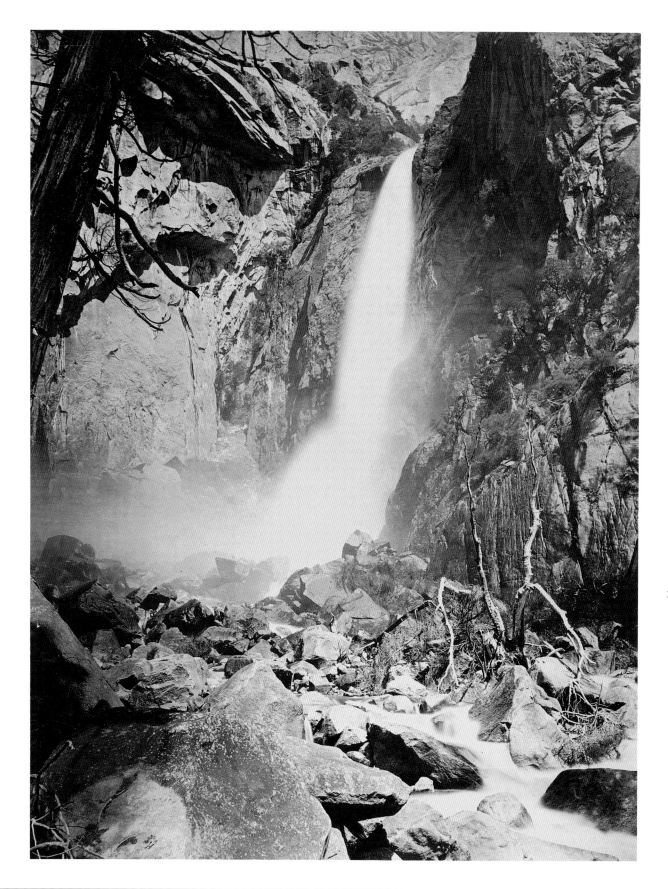

Carleton E. Watkins
1829–1916
THE LOWER YOSEMITE
FALL, 418 FEET
c. 1861
Albumen print, mammoth plate

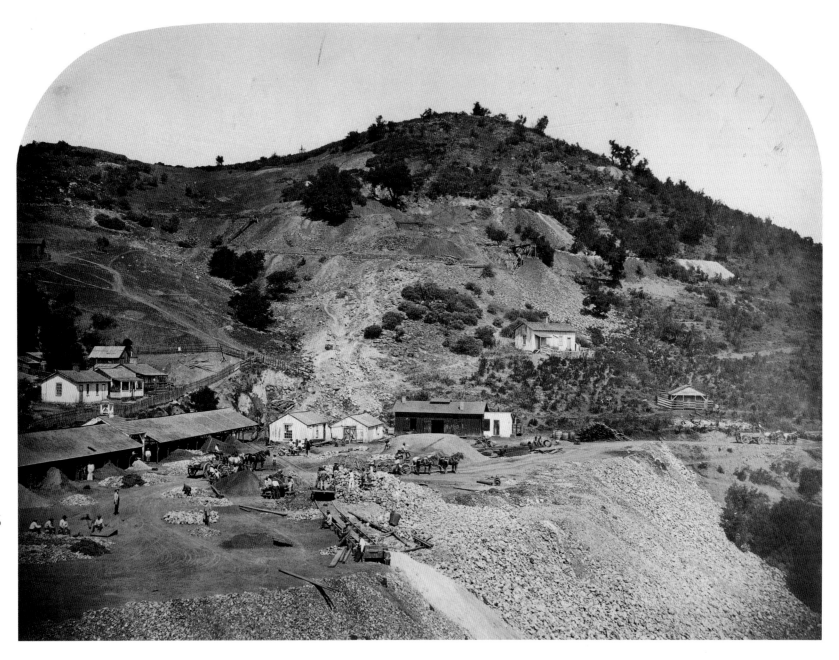

26

Carleton E. Watkins
1829–1916
NEW ALMADEN
QUICKSILVER MINE
1863
Albumen print

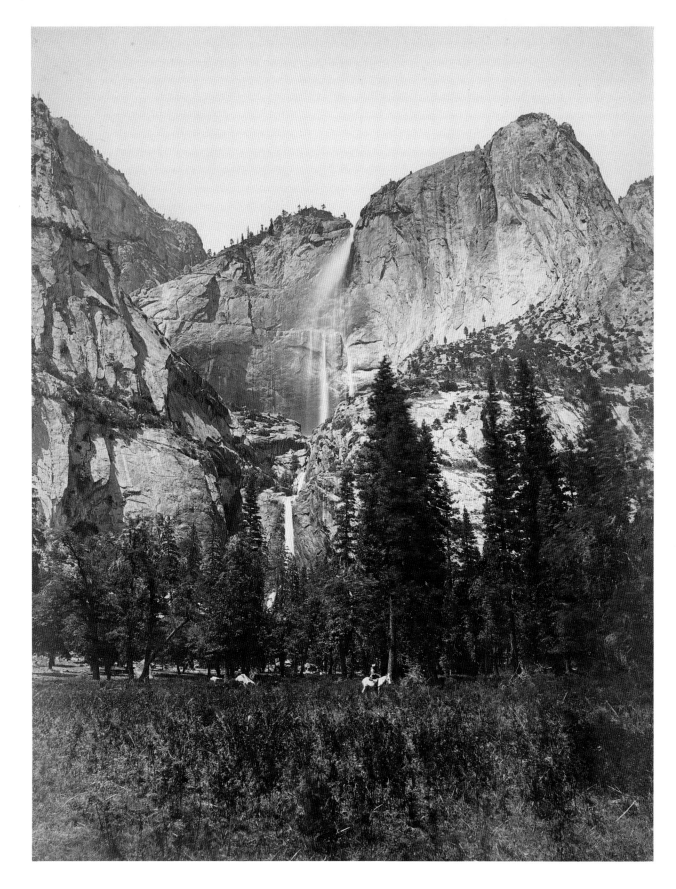

Charles Leander Weed
1828–1903
THE YOSEMITE FALL,
2634 FEET HIGH
c. 1863
Albumen print

27

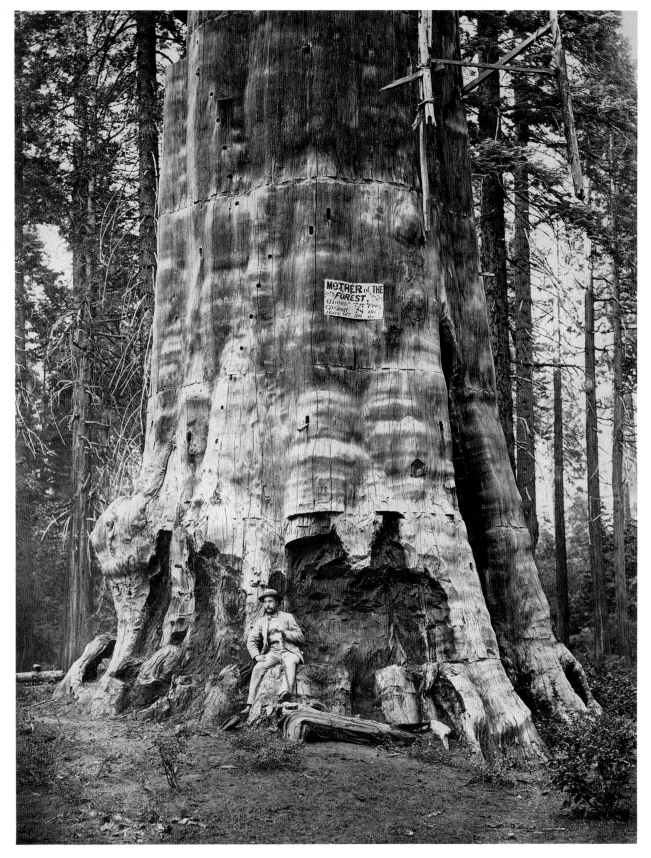

Unidentified photographer
MOTHER OF THE FOREST,
305 FEET HIGH,
MAMMOTH GROVE
c. 1870
Albumen print

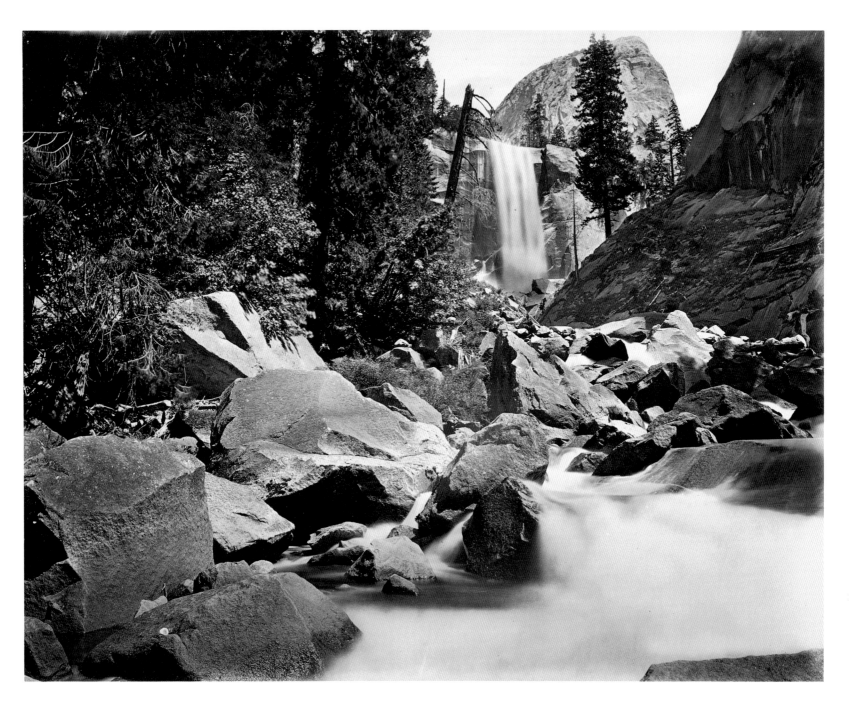

Eadweard Muybridge
1830–1904
PI-WI-ACK, VALLEY OF
THE YOSEMITE
1872
Albumen print, mammoth plate

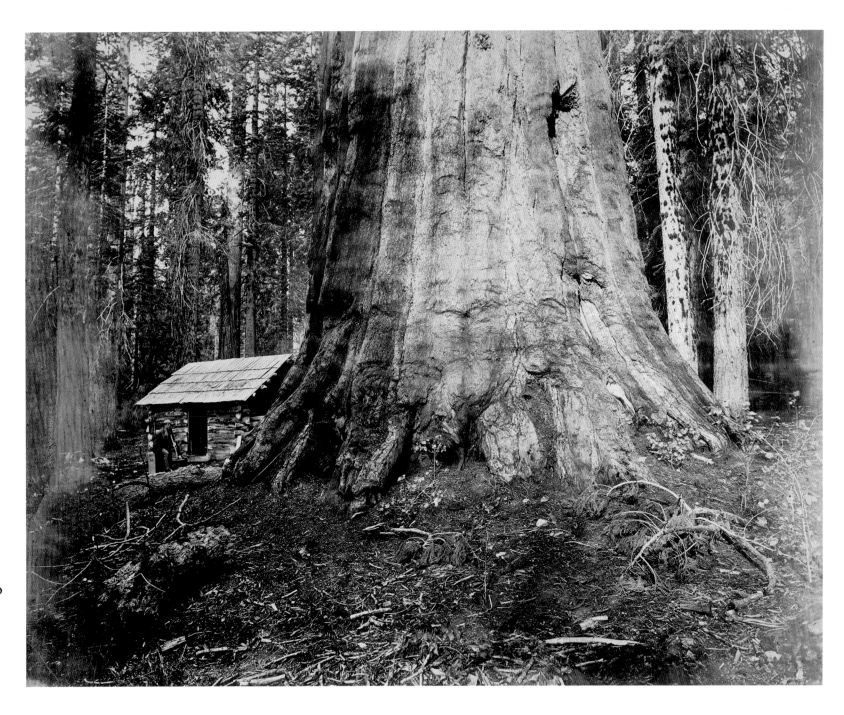

30

Eadweard Muybridge
1830–1904
MARIPOSA GROVE OF
MAMMOTH TREES
1872
Albumen print, mammoth plate

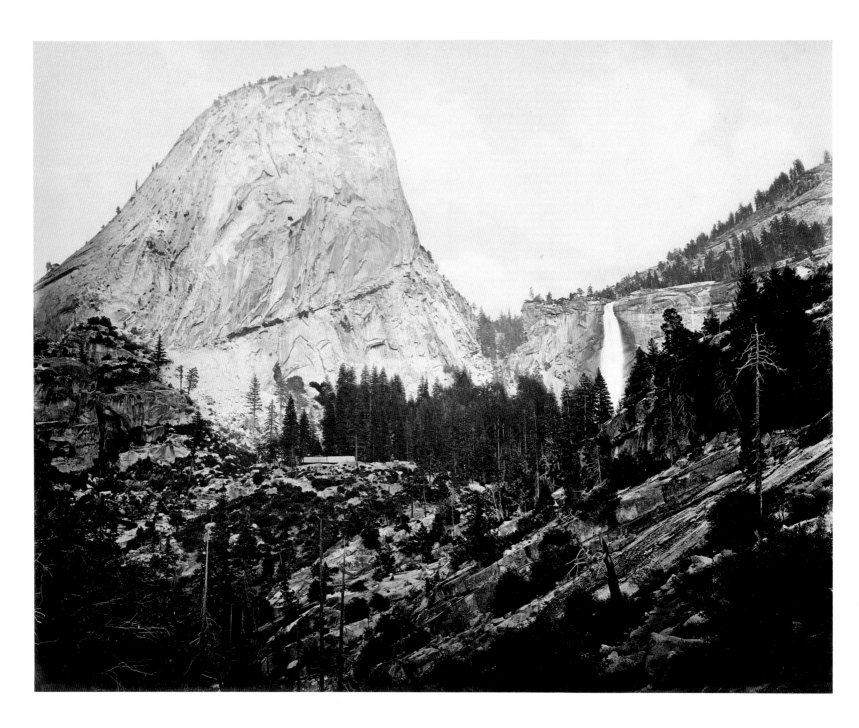

31

Eadweard Muybridge
1830–1904
CAP OF LIBERTY, VALLEY OF
THE YOSEMITE
1872
Albumen print, mammoth plate

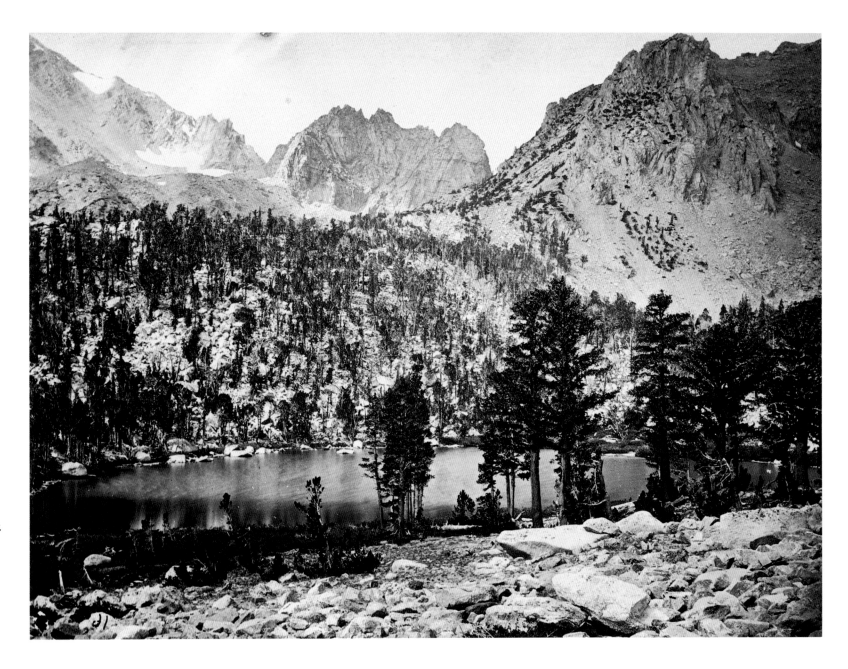

Timothy O'Sullivan
c. 1840–1882
ALPINE LAKE IN THE SIERRA
NEVADA, CALIFORNIA
c. 1871
Albumen print

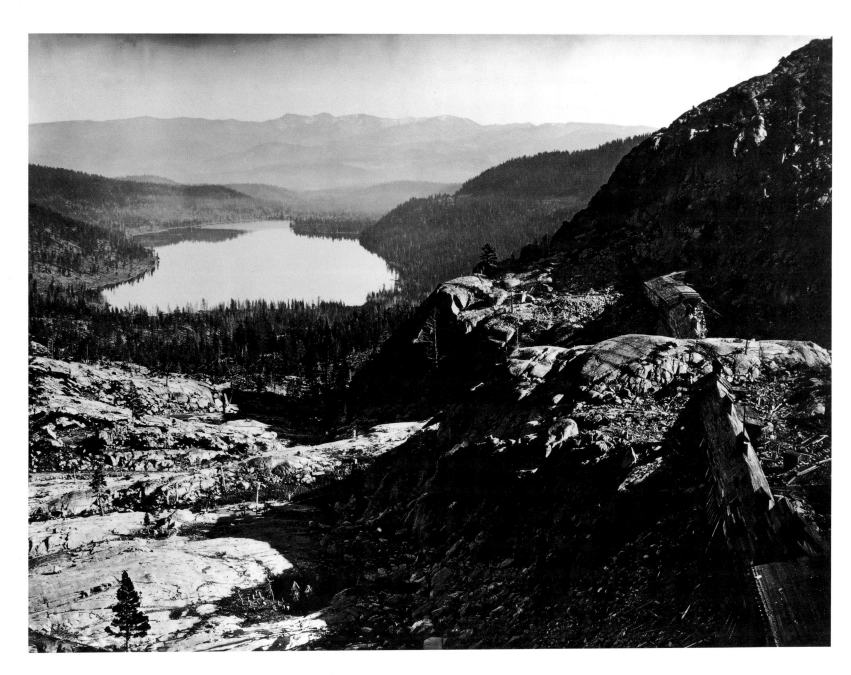

33

Andrew Joseph Russell
1830–1902

DONNER LAKE, SIERRA
NEVADA MOUNTAINS,
SNOW SHED TUNNELS IN
FOREGROUND
1869/1988

Solar print made from Russell's original
imperial glass-plate negative

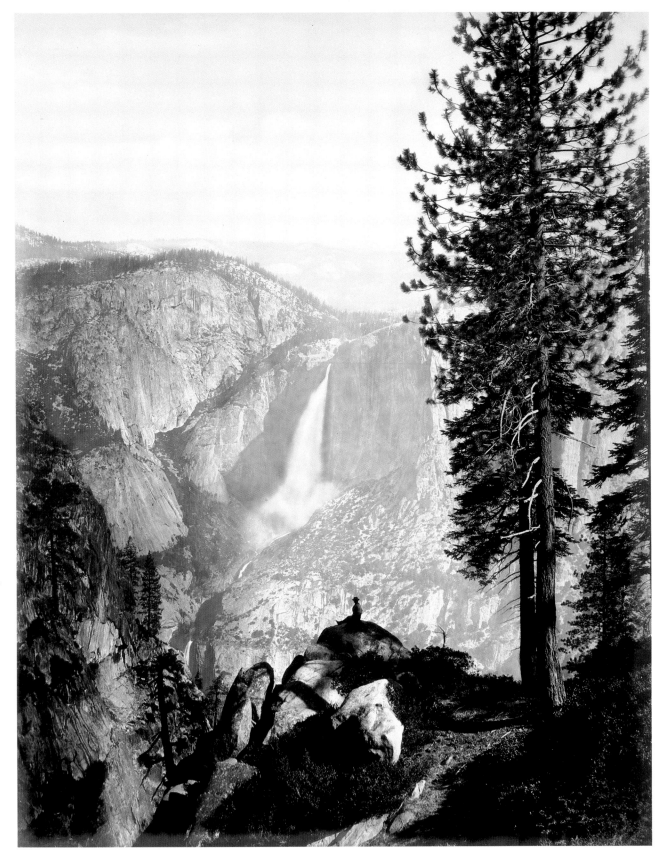

34

Eadweard Muybridge
1830–1904
FALLS OF THE YOSEMITE,
FROM GLACIER ROCK
1872
Albumen print, mammoth plate

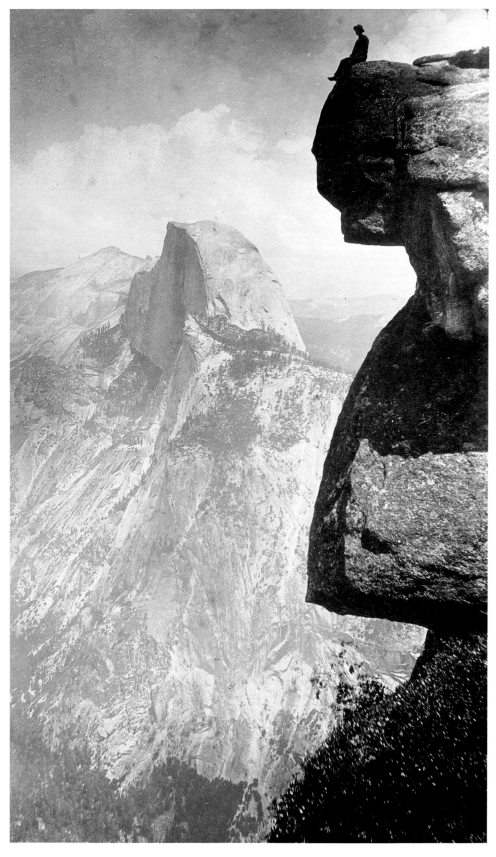

35

George Fiske
1835–1918
HALF DOME (5000 FEET) AND
GLACIER POINT (3200 FEET),
YOSEMITE VALLEY
c. 1880
Albumen print

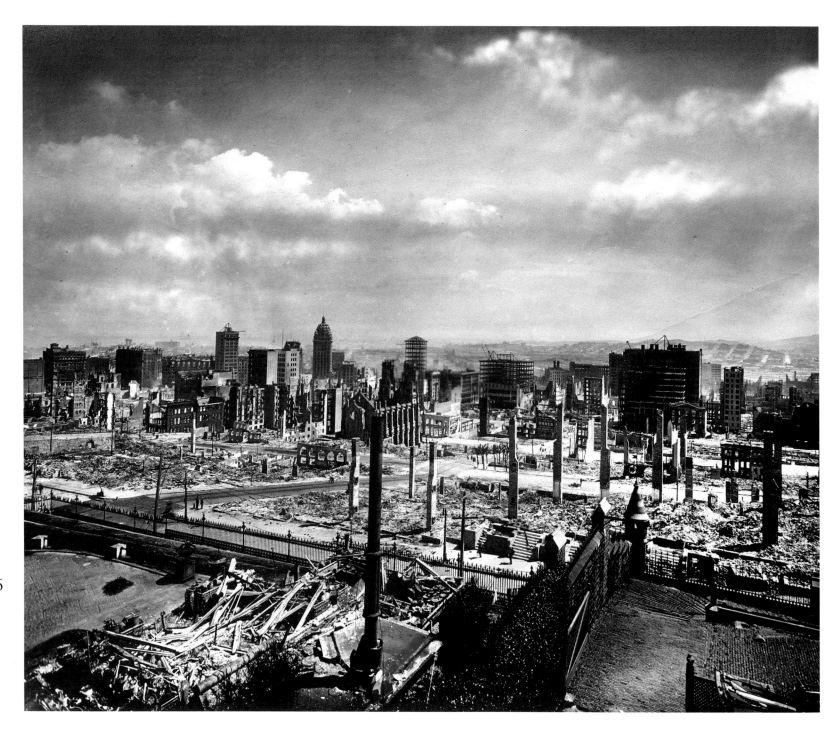

36

Willard Worden
1868–1946
RUINED CITY, EAST
FROM NOB HILL
1906
Gelatin silver print

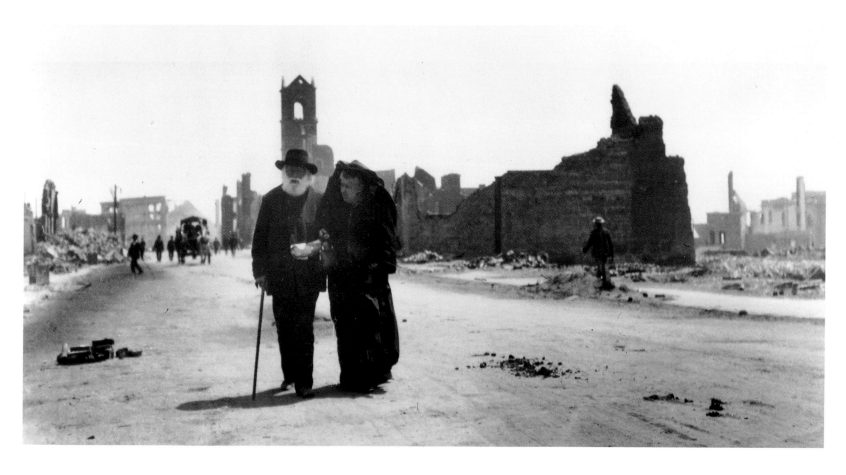

Oscar Maurer
1871–1965
HOMELESS
1906/1950
Gelatin silver print

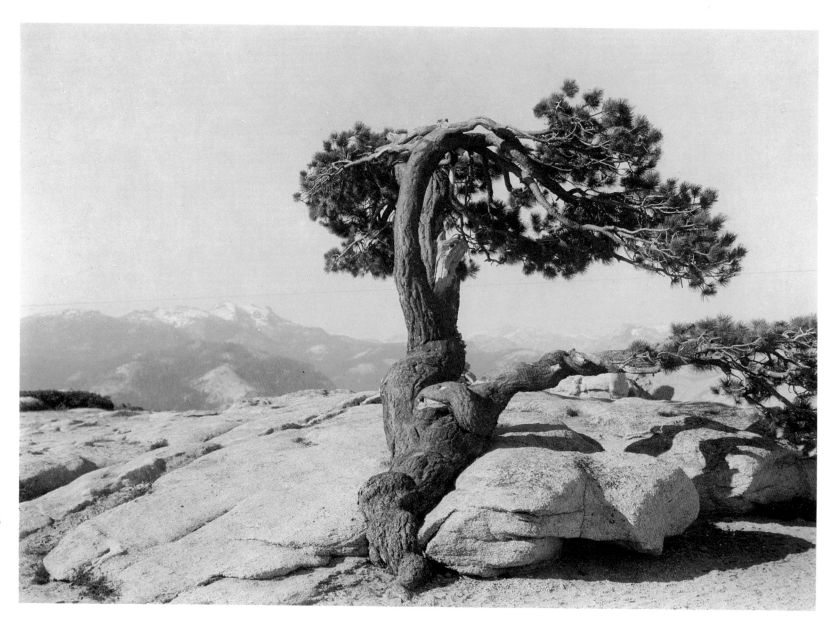

38

Herbert W. Gleason
1855–1937
JEFFREY PINES ON SENTINEL
DOME, YOSEMITE
c. 1908
Palladium print

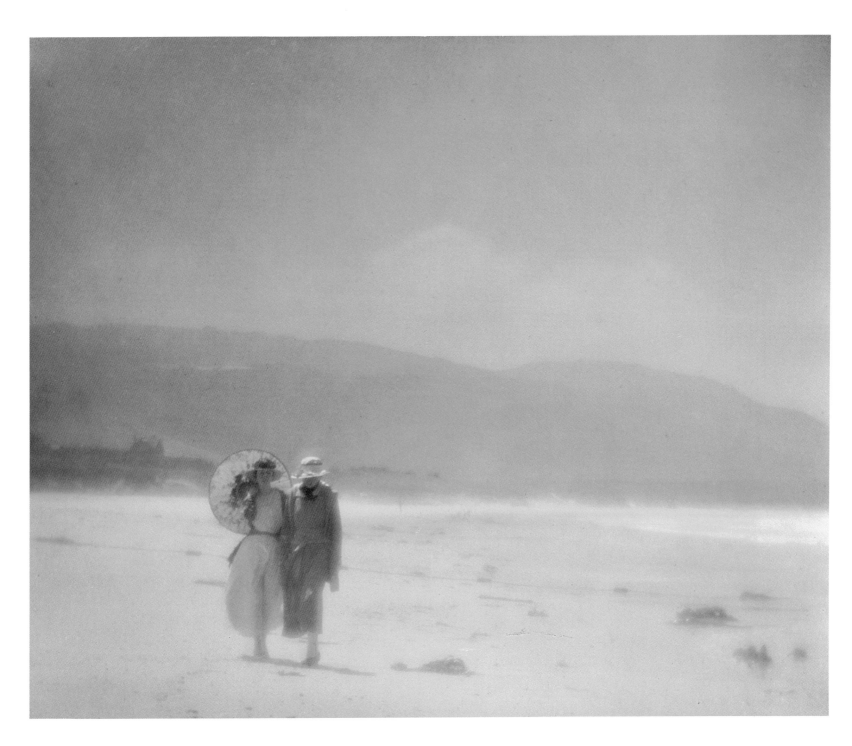

John Paul Edwards
1884–1969
THE STROLLERS, CARMEL
BEACH, MONTEREY COAST
1918
Gelatin silver print

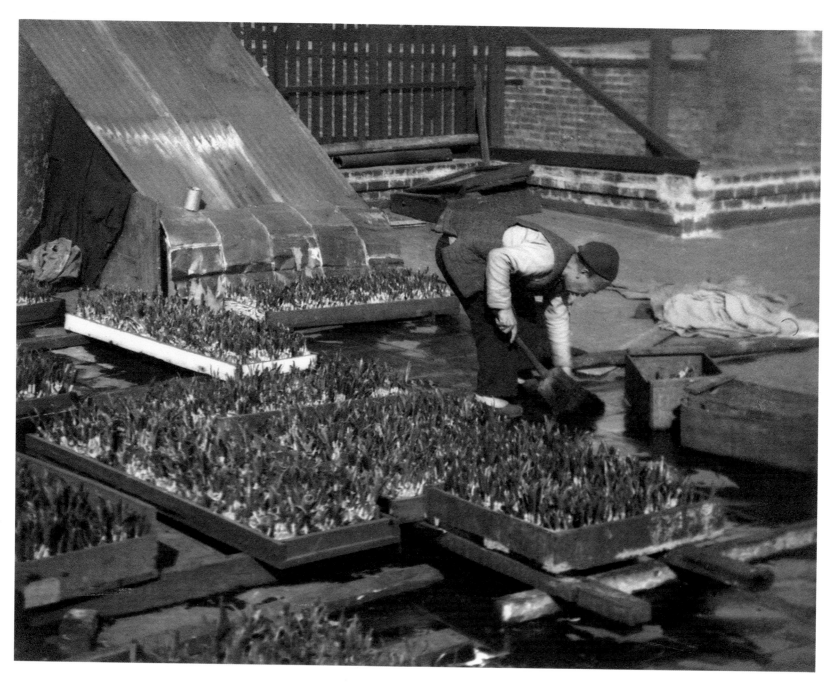

40

Arnold Genthe
1869–1942
UNTITLED
Between 1895 and 1911
Gelatin silver print

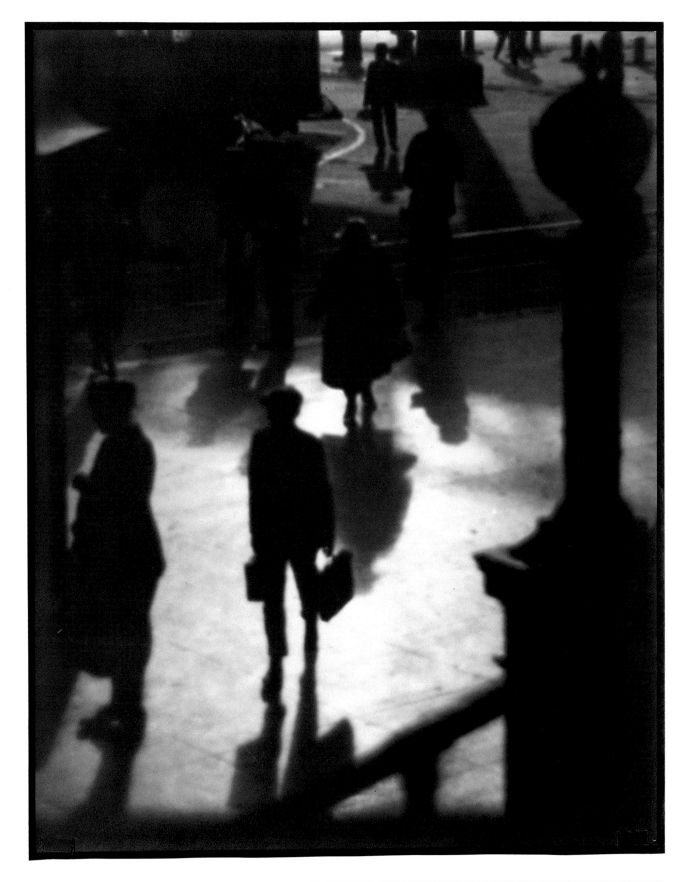

41

Johan Hagemeyer
1884–1962
PEDESTRIANS
1922
Gelatin silver print

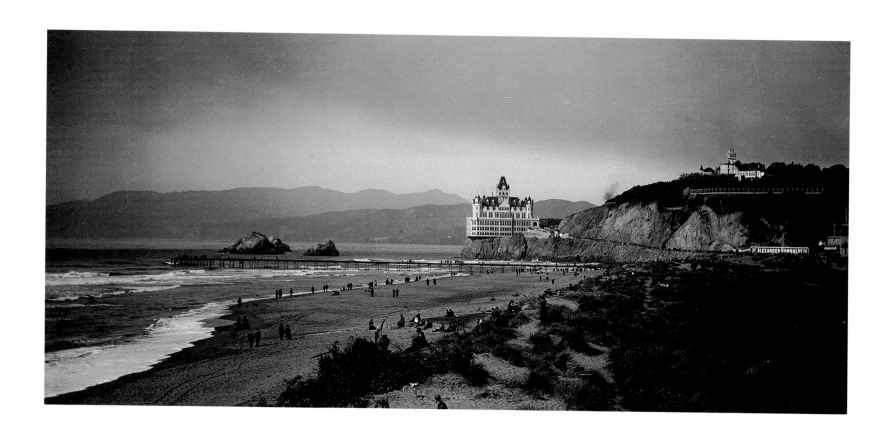

42

Unidentified photographer
UNTITLED
c. 1900
Toned cabinet photograph

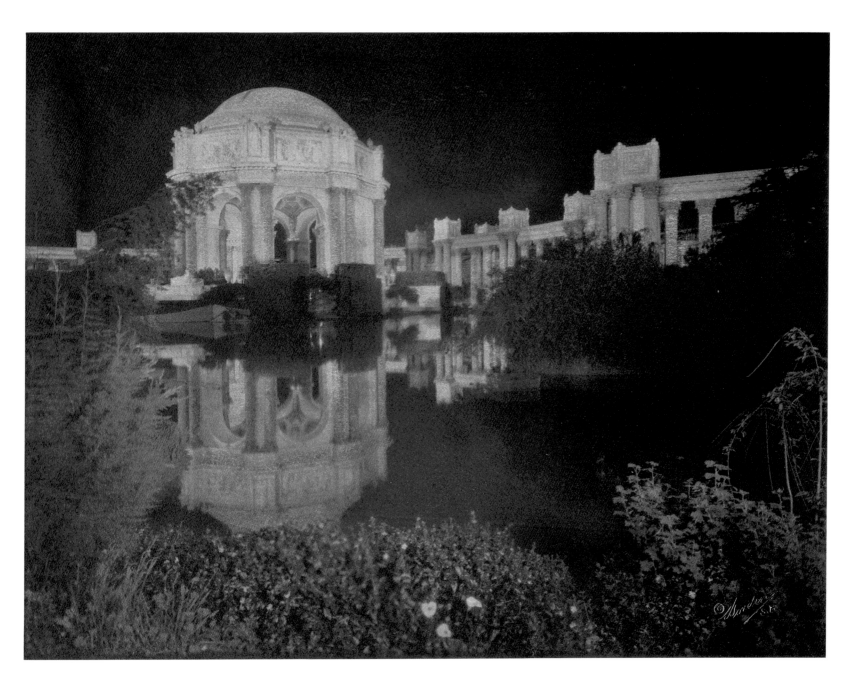

43

Willard Worden
1873–1946
UNTITLED
1915
Gelatin silver print, hand-tinted

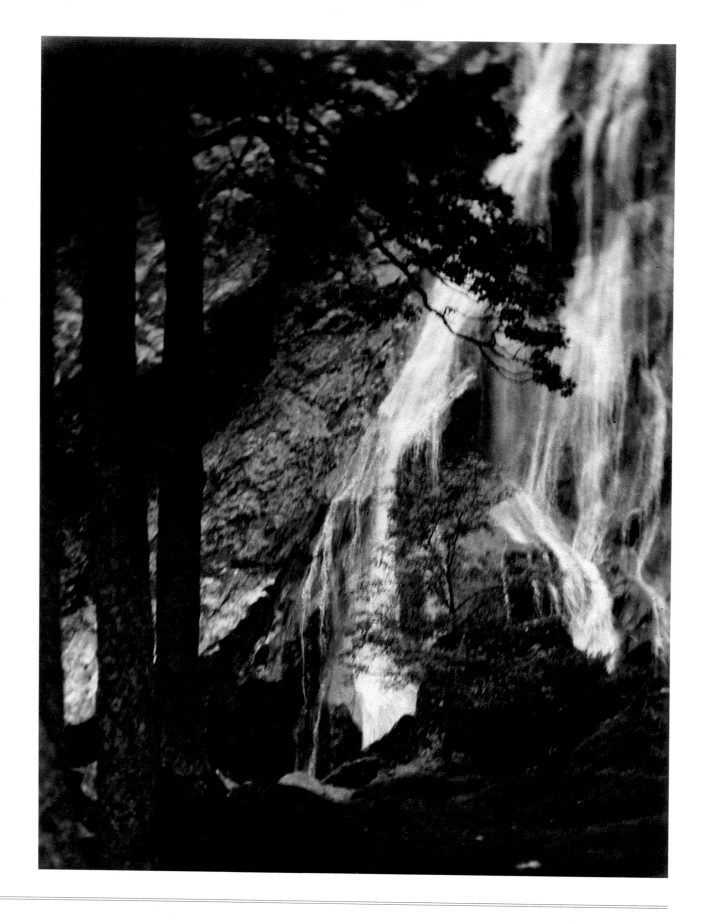

44

Alvin Langdon Coburn
1882–1936
CALIFORNIA,
YOSEMITE FALLS
c. 1920
Platinum print

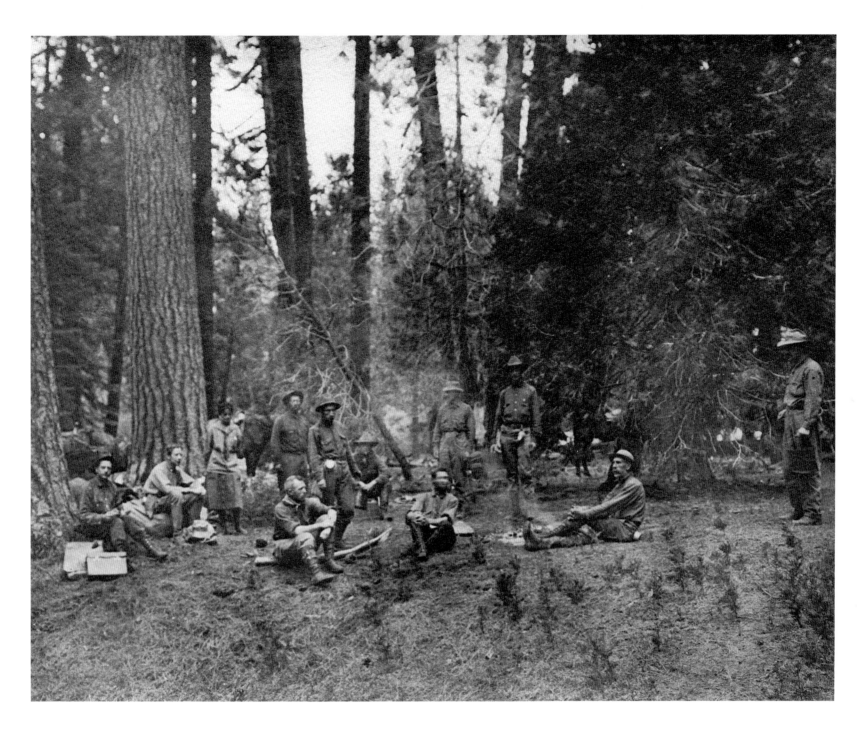

45

Andrew Barnaby McKinne
1881–1966
YOSEMITE SCENES,
SIERRA CLUB
c. 1910
Toned print

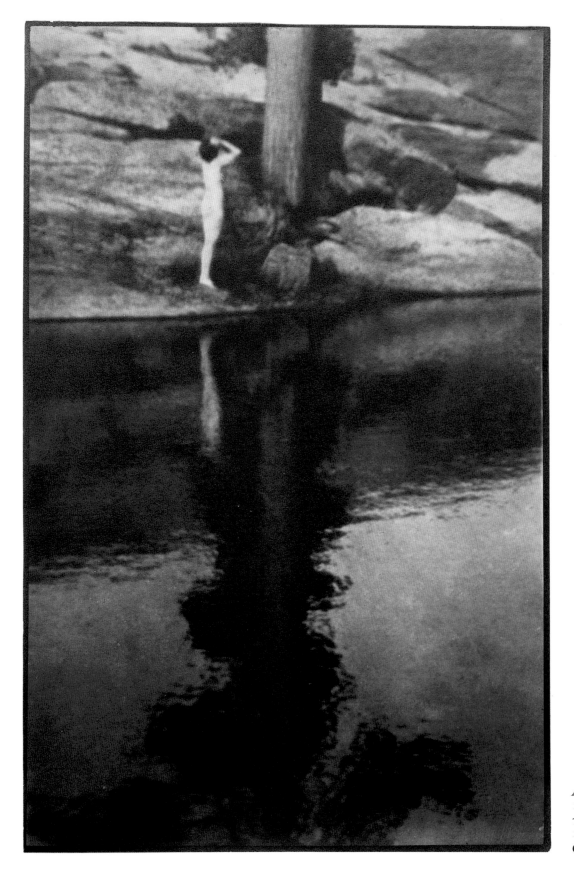

Anne Brigman
1869–1950
THE LIMPID POOL
1909
Gelatin silver print

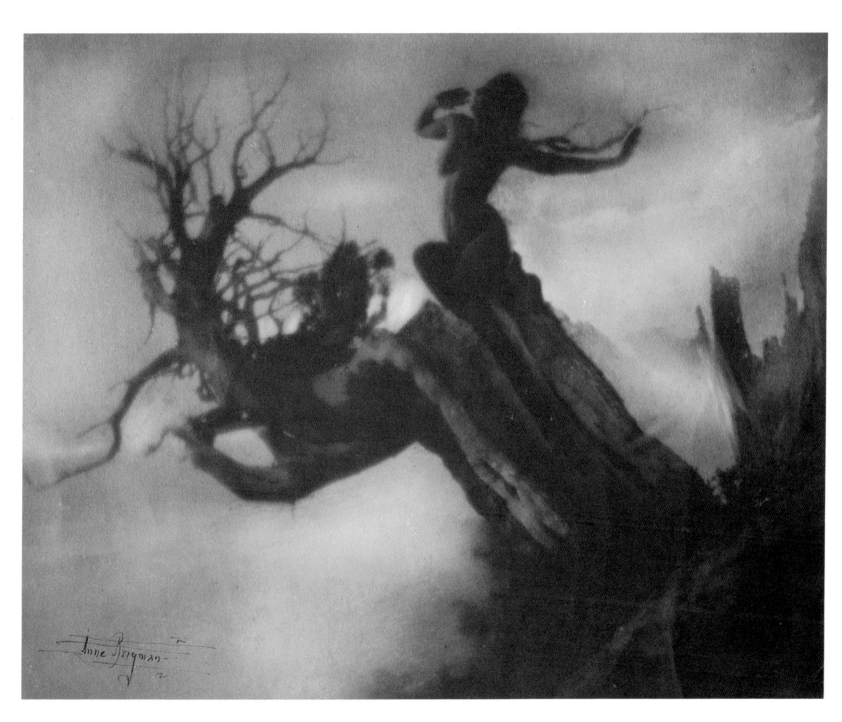

Anne Brigman
1869–1950
THE STORM TREE
1911
Gelatin silver print

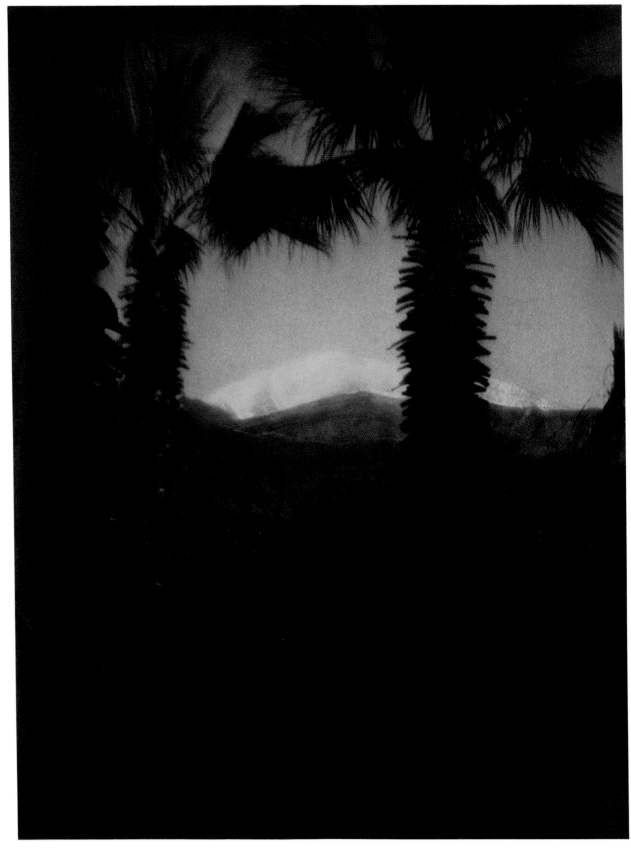

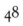

Karl Struss
1886–1981
IN THE SOUTHLAND,
MT. BALDY, CALIFORNIA
c. 1921
Gum platinum print

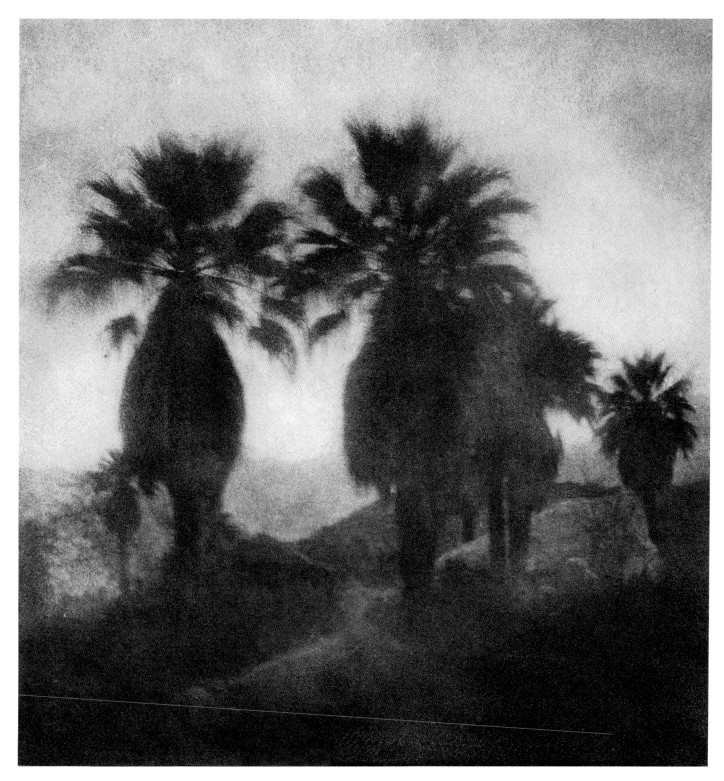

49

Alice Burr
1883–1968
UNTITLED
c. 1925
Bromoil transfer print

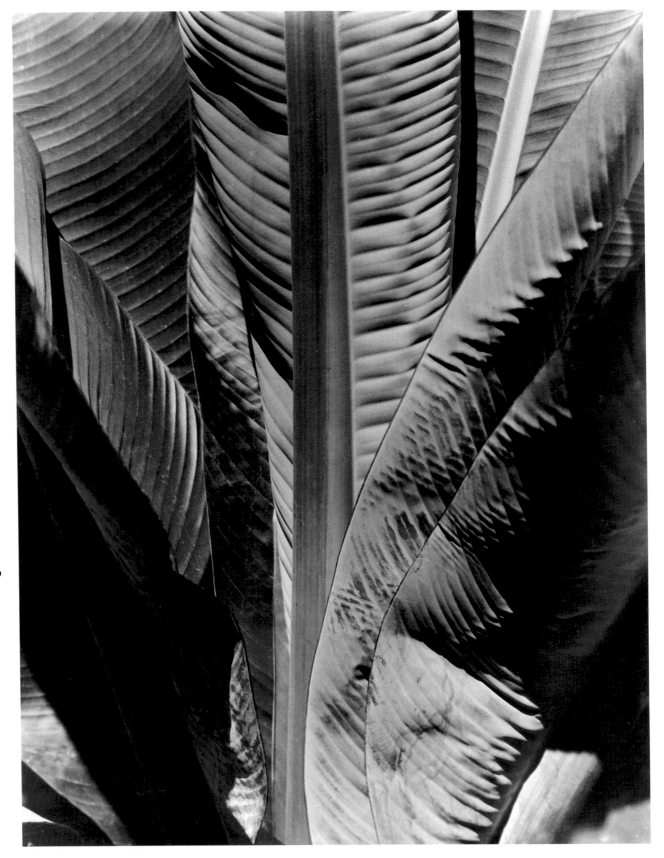

50

Imogen Cunningham
1883–1976
BANANA PLANT
c. 1924
Gelatin silver print

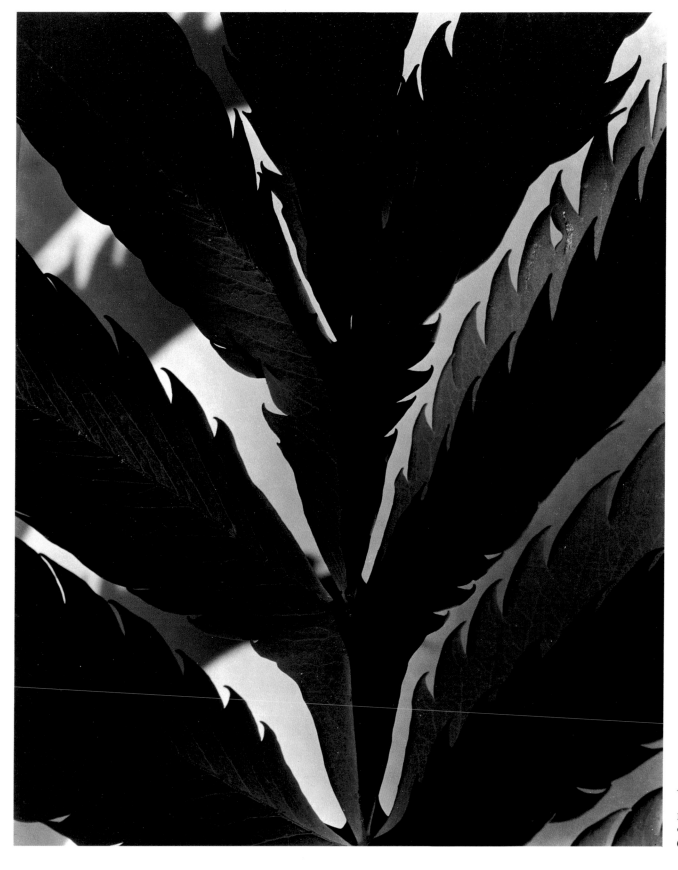

51

Imogen Cunningham
1883–1976
LEAF PATTERN
c. 1924
Gelatin silver print

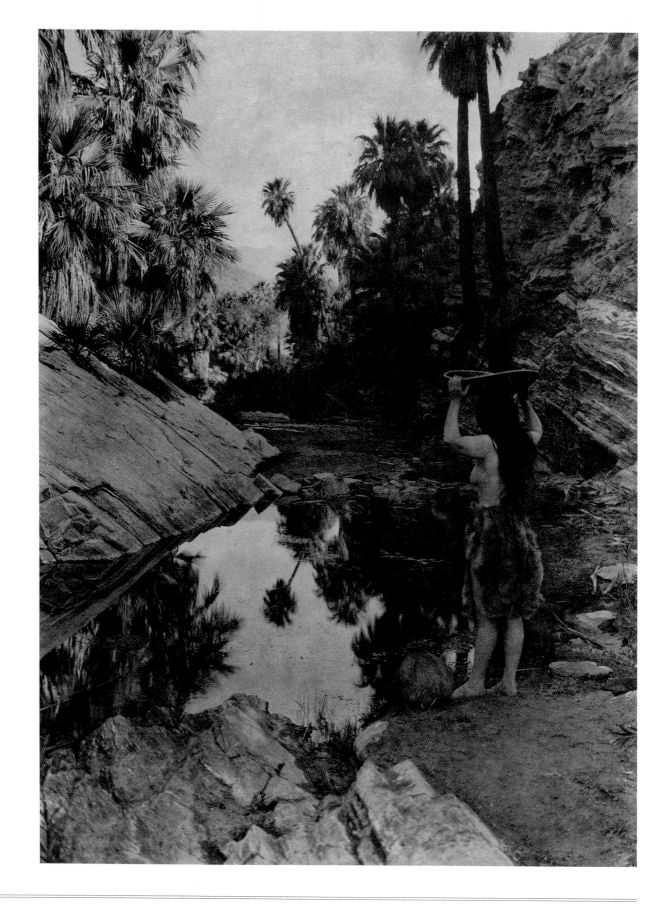

52

Edward Sheriff Curtis
1869–1952

BEFORE THE WHITE MAN
CAME, PALM CAÑON
1924
Photogravure

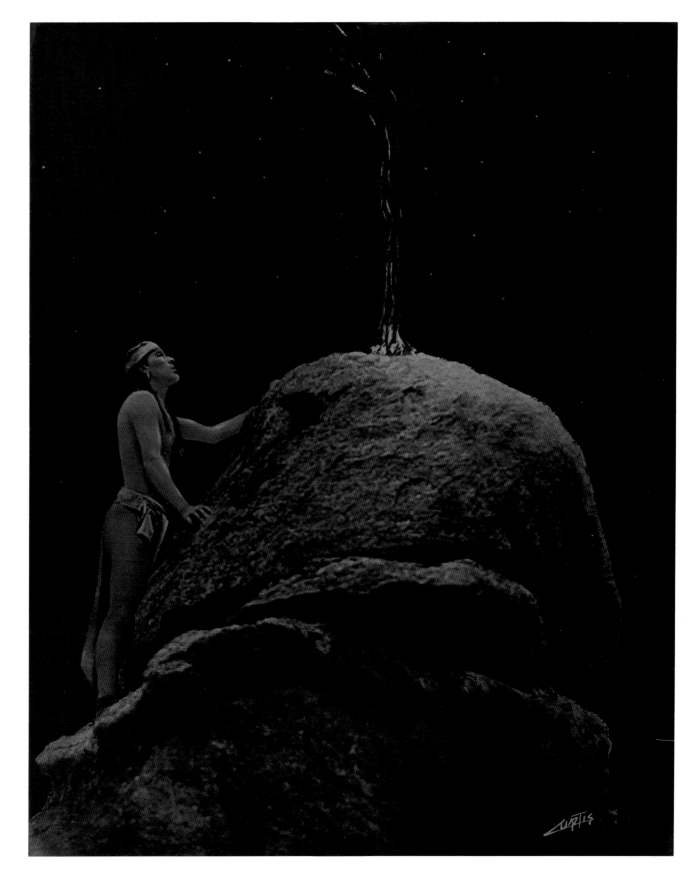

Edward Sheriff Curtis
1869–1952
SIGNAL FIRE TO THE
MOUNTAIN GOD
c. 1925
Orotone on glass

53

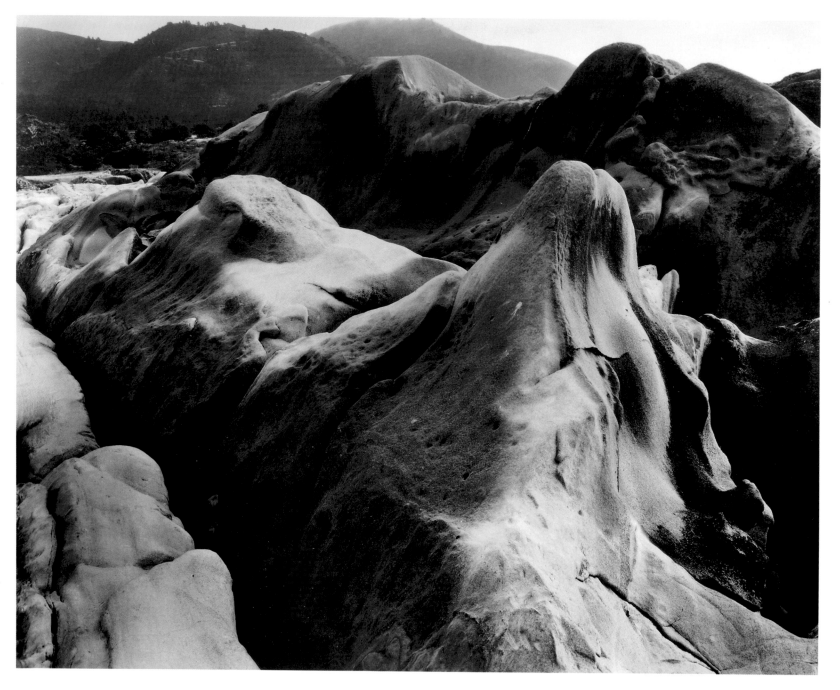

54

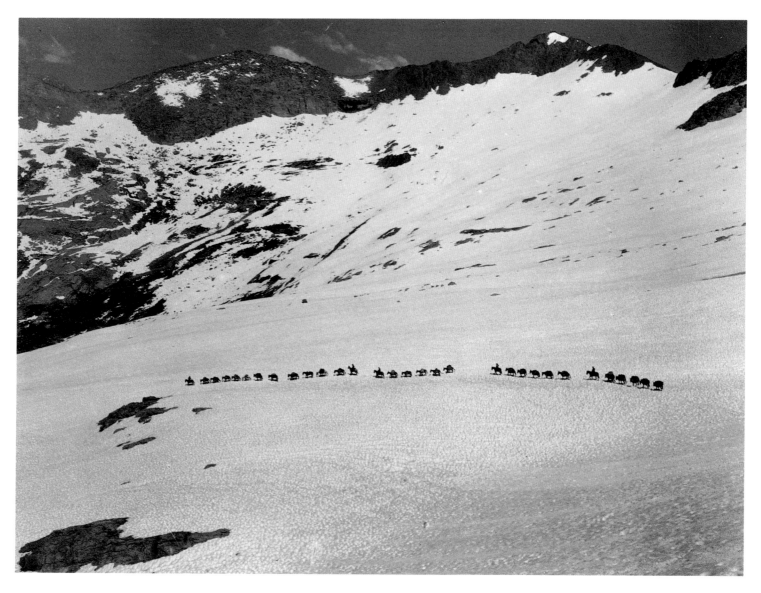

Ansel Adams
1902–1984
BLACK ROCK PASS,
THE HIGH SIERRA,
PACK TRAINS IN SNOW
c. 1927
Gelatin silver print

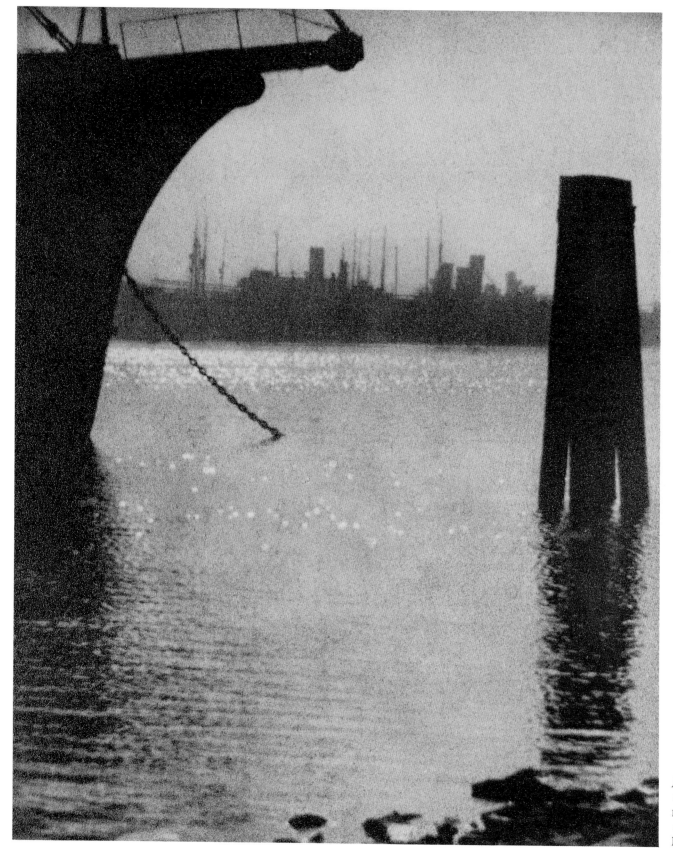

Henry A. Hussey
1887–1957
BONE YARD
1926
Bromoil print

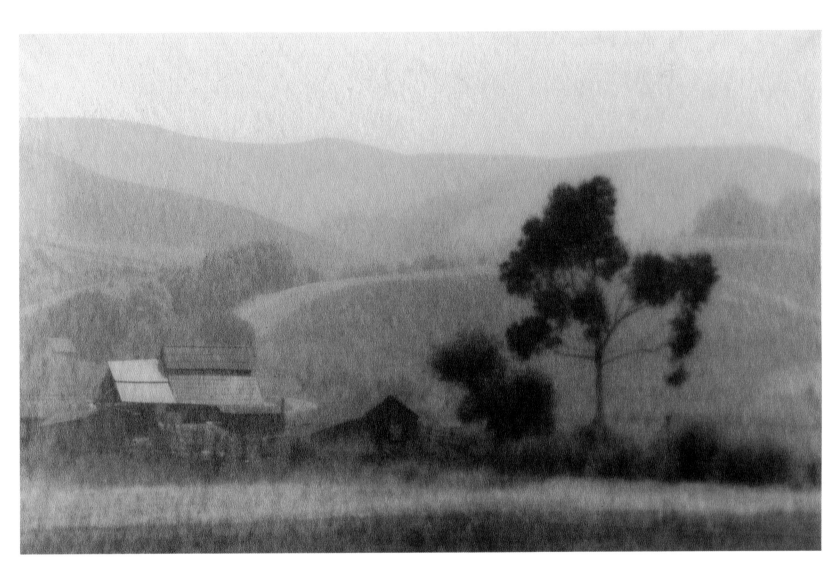

57

William Edward Dassonville
1879–1957
UNTITLED
c. 1929
Charcoal Black silver print

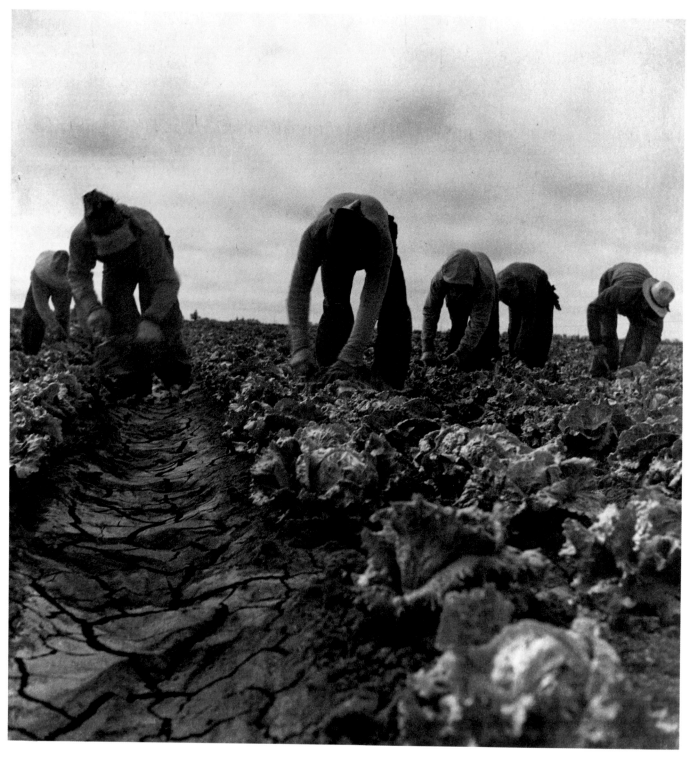

58

Dorothea Lange
1895–1965
FILIPINOS CUTTING LETTUCE,
SALINAS VALLEY
1935/1988
Gelatin silver print

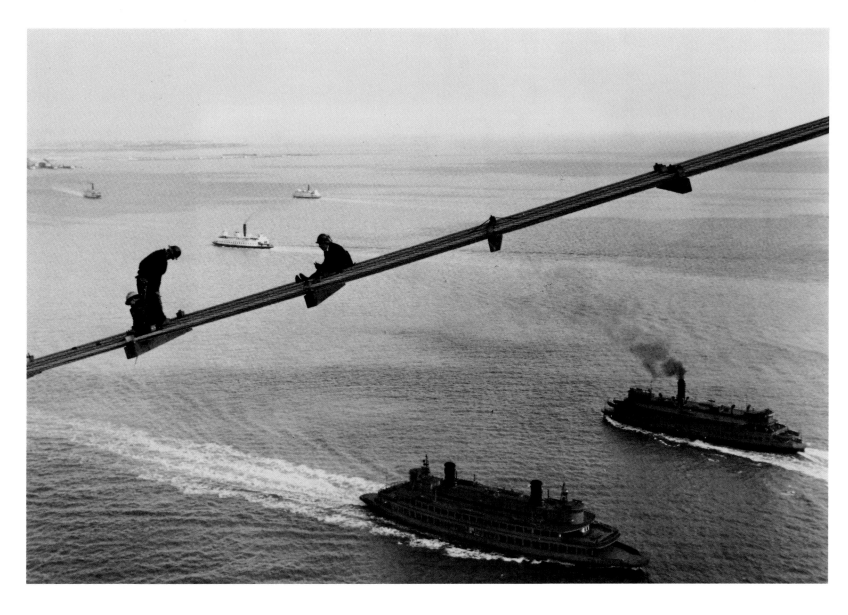

59

Peter Stackpole
1913–
WAITING ON CATWALK
1935
Gelatin silver print

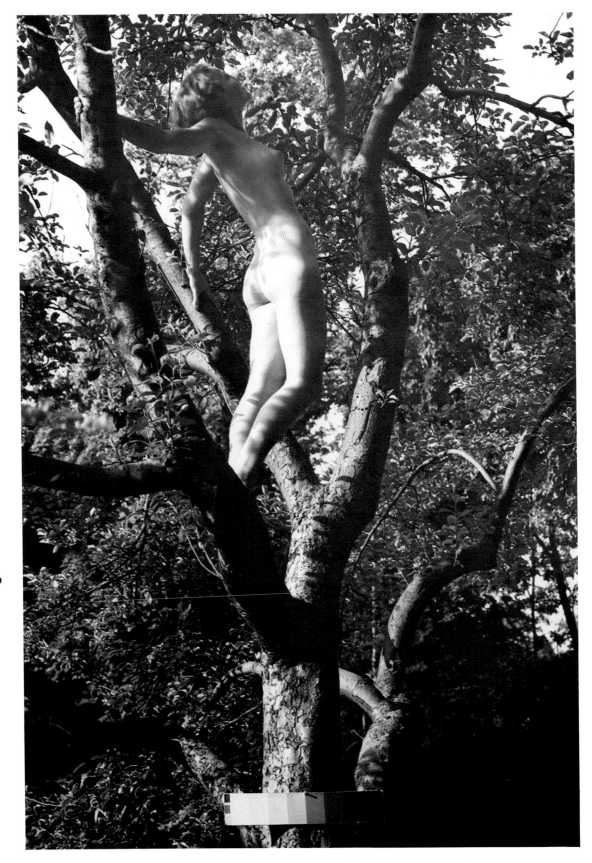

60

Paul Outerbridge
1896–1958
UNTITLED
1936
Tri-color carbro print

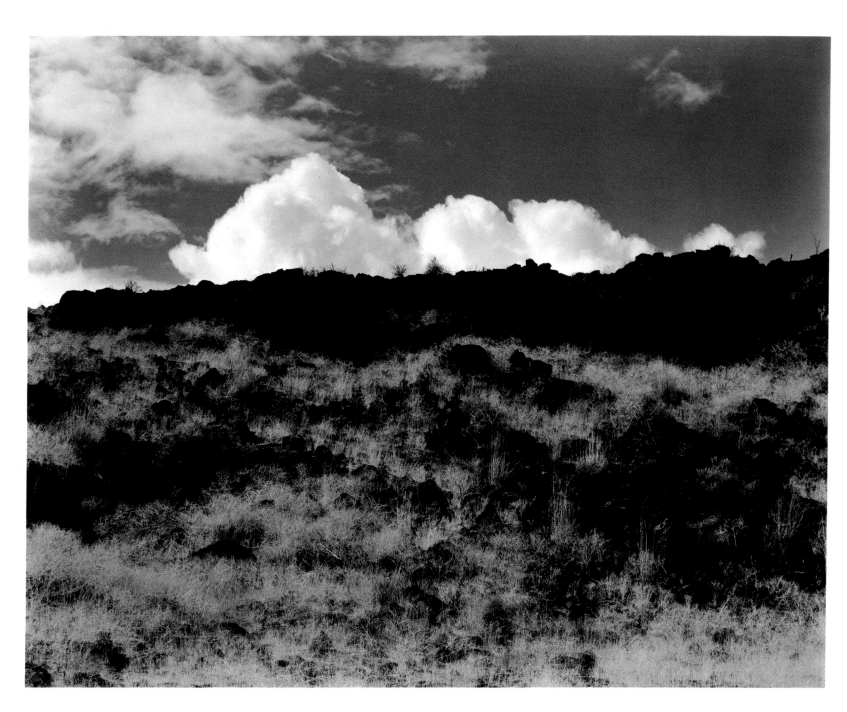

61

Edward Weston
1886–1958
MODOC LAVA FLATS
1937
Gelatin silver print

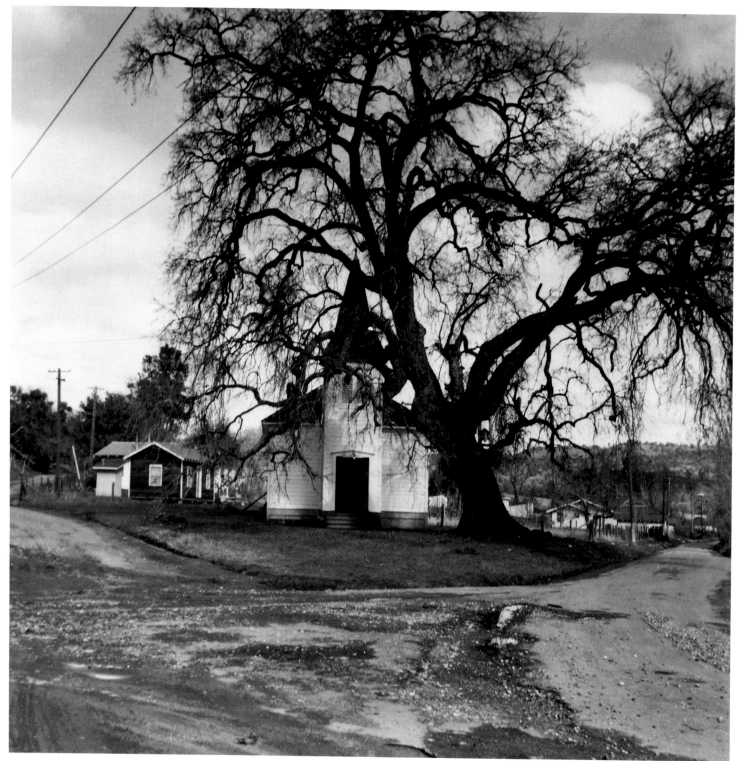

62

Alma Lavenson
1897–
CHURCH, VALLECITO
1938
Gelatin silver print

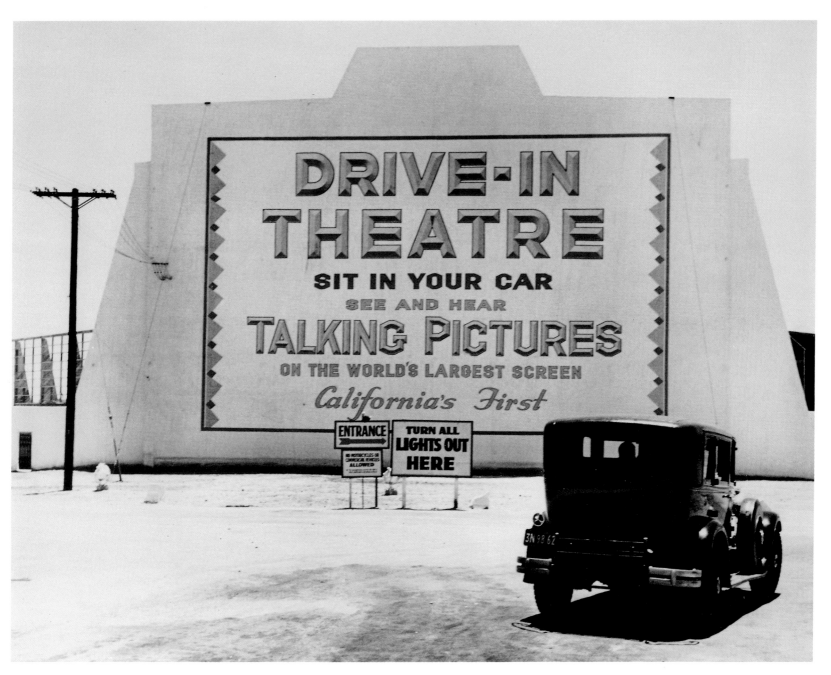

63

John Gutmann
1905–
FIRST DRIVE-IN THEATRE
1935/1988
Gelatin silver print

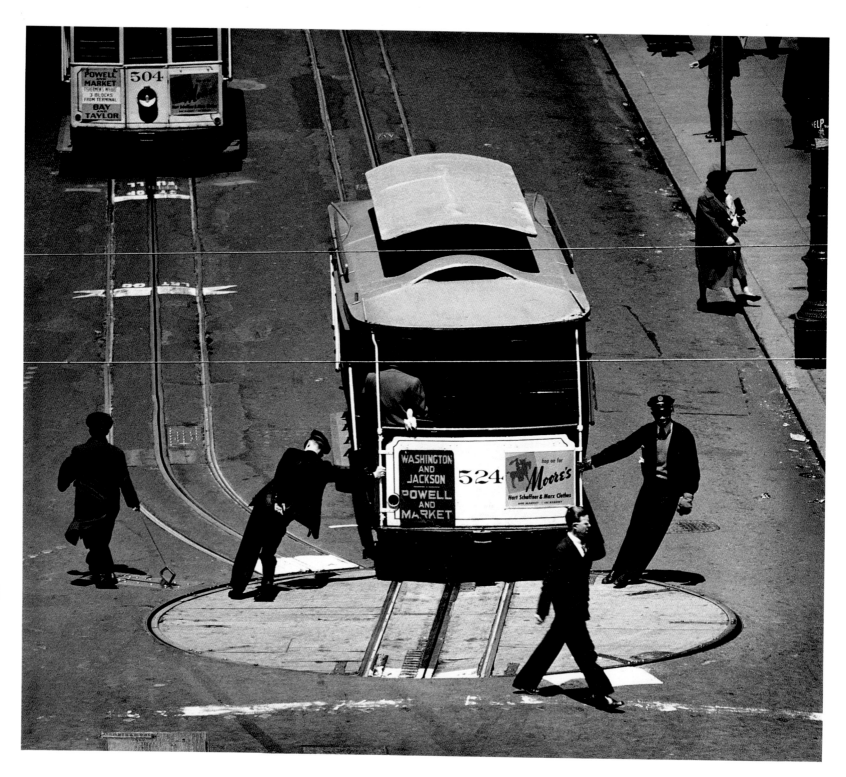

64

Max Yavno
1911–1985
CABLE CAR, SAN FRANCISCO
1947
Gelatin silver print

65

Man Ray
1890–1976
UNTITLED
c. 1940
Gelatin silver print

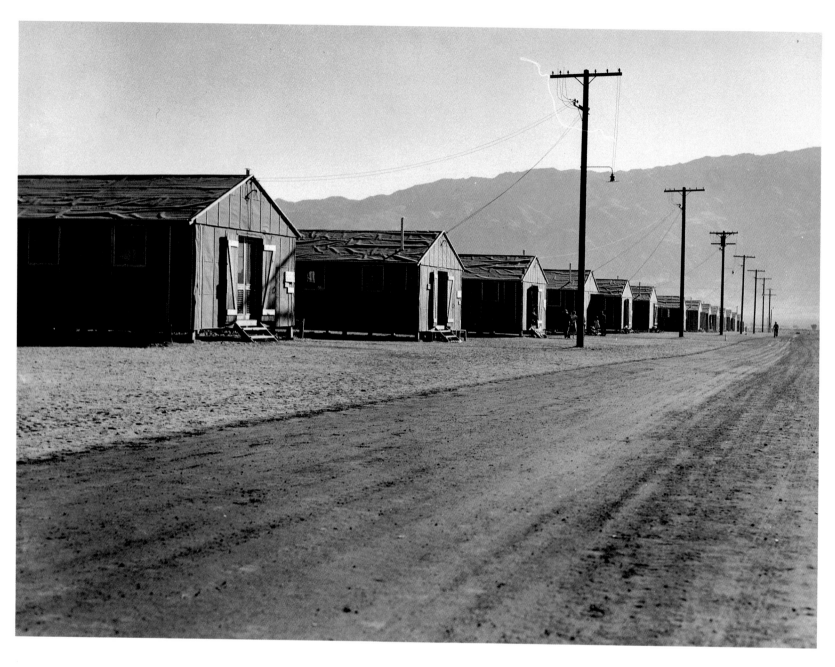

66

Dorothea Lange
1895–1965
MANZANAR RELOCATION
CENTER
1942
Gelatin silver print

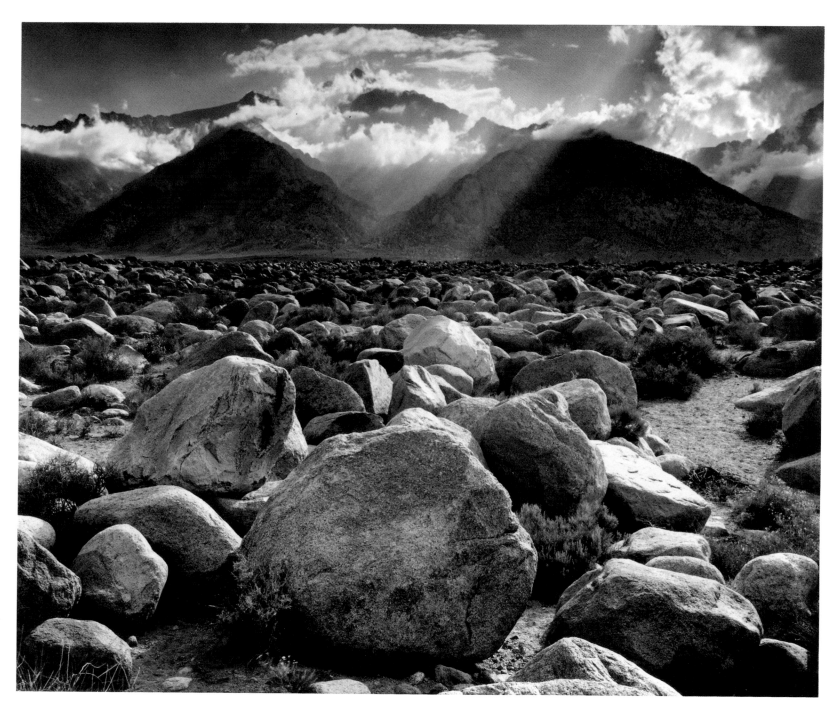

67

Ansel Adams
1902–1984
MOUNT WILLIAMSON, THE
SIERRA NEVADA, FROM
MANZANAR, CALIFORNIA
1945
Gelatin silver print

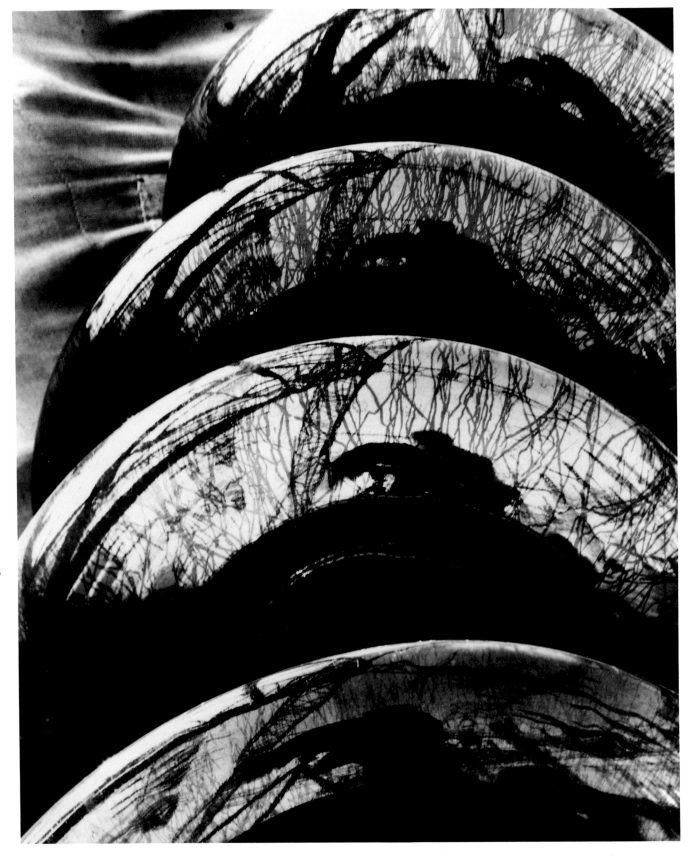

68

Minor White
1908–1976
INSULATORS, NEWARK
SUBSTATION, PG&E
1947
Gelatin silver print

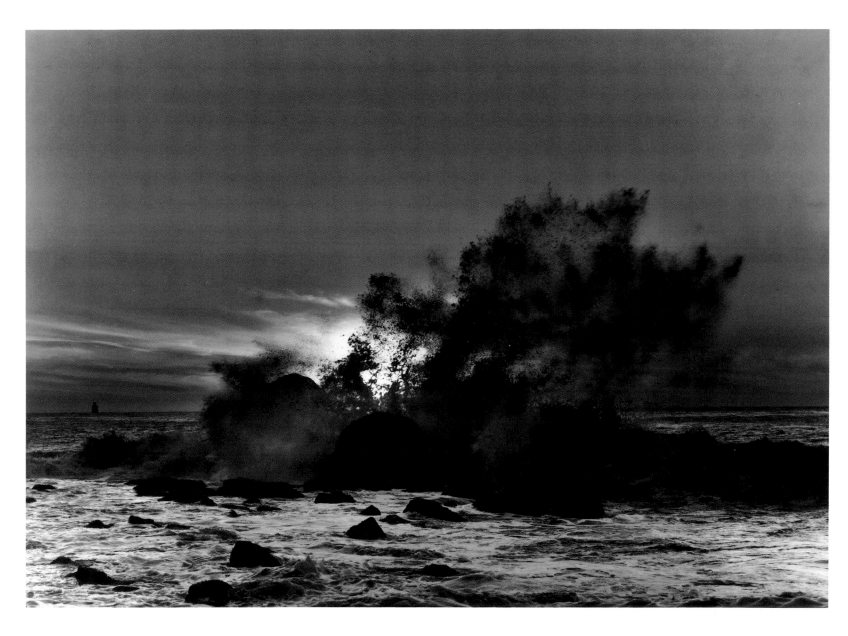

69

Pirkle Jones
1914–
BREAKING WAVE, GOLDEN
GATE, SAN FRANCISCO
1952
Gelatin silver print

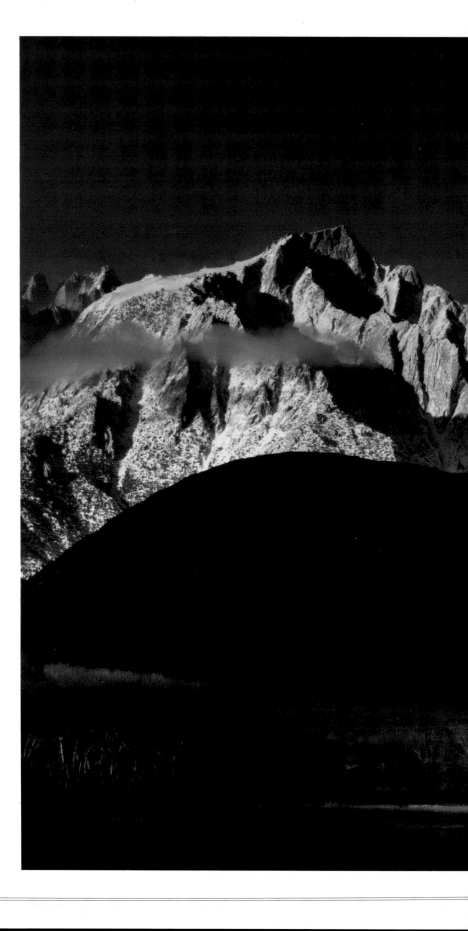

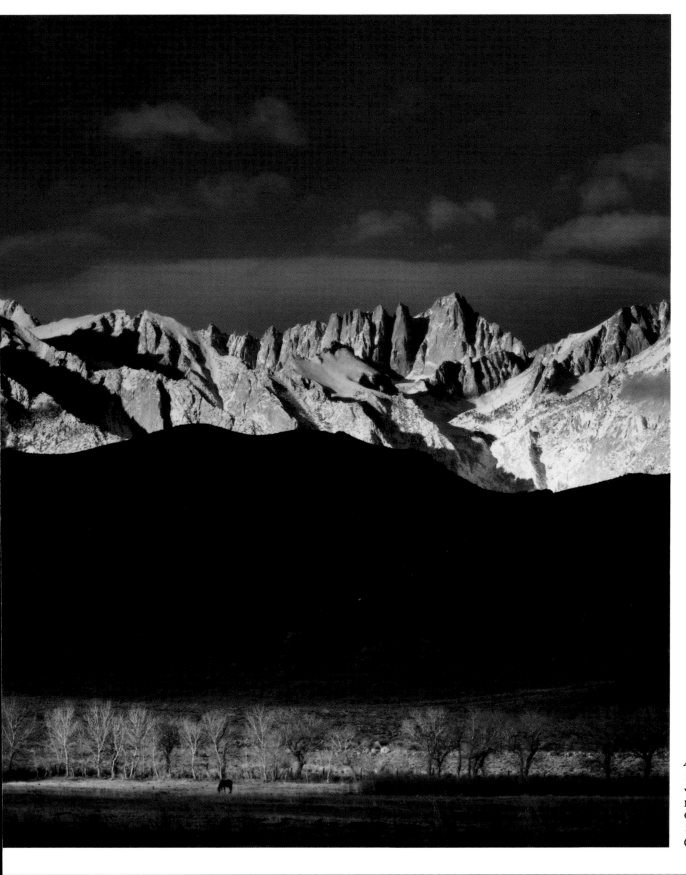

71

Ansel Adams
1902–1984
WINTER SUNRISE, THE SIERRA
NEVADA, FROM LONE PINE,
CALIFORNIA
1944
Gelatin silver print

Dorothea Lange
1895–1965
TRACT LIVING, NEAR MILPITAS
1954/1988
Gelatin silver print

73

Dorothea Lange
1895–1965
U.S. HIGHWAY 40
1956
Gelatin silver print

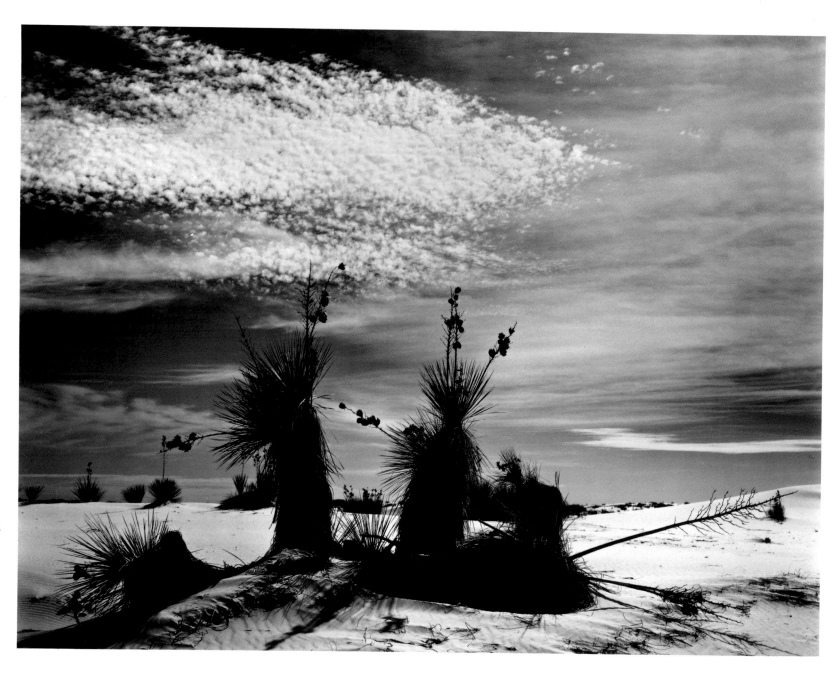

Brett Weston
1911–
UNTITLED
1947
Gelatin silver print

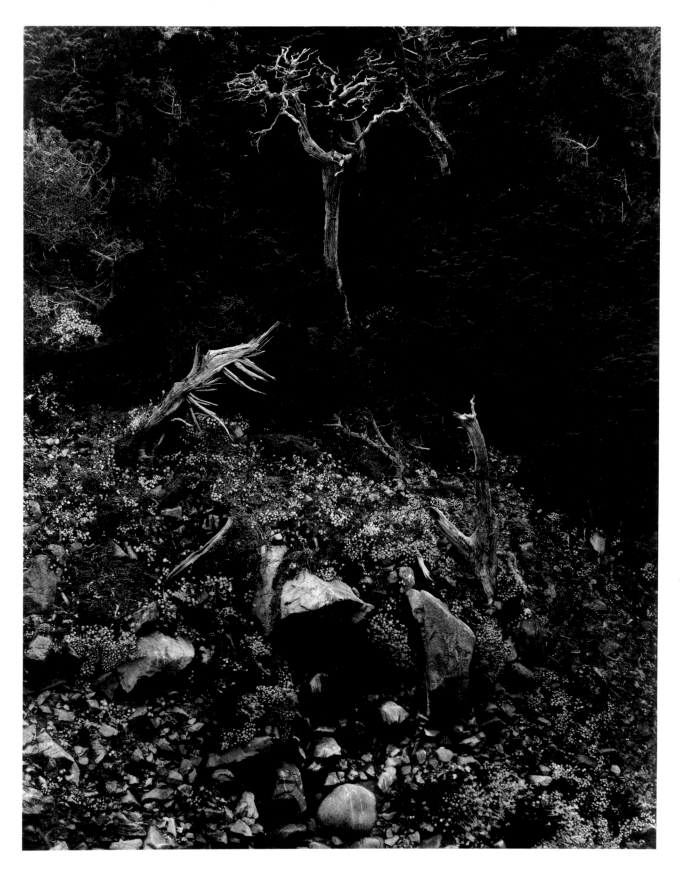

Edward Weston
1886–1958
NORTH DOME,
POINT LOBOS
1946
Gelatin silver print

Helen Nestor
1924–
THE FREE SPEECH
MOVEMENT SIT-IN
1964/1988
Gelatin silver print

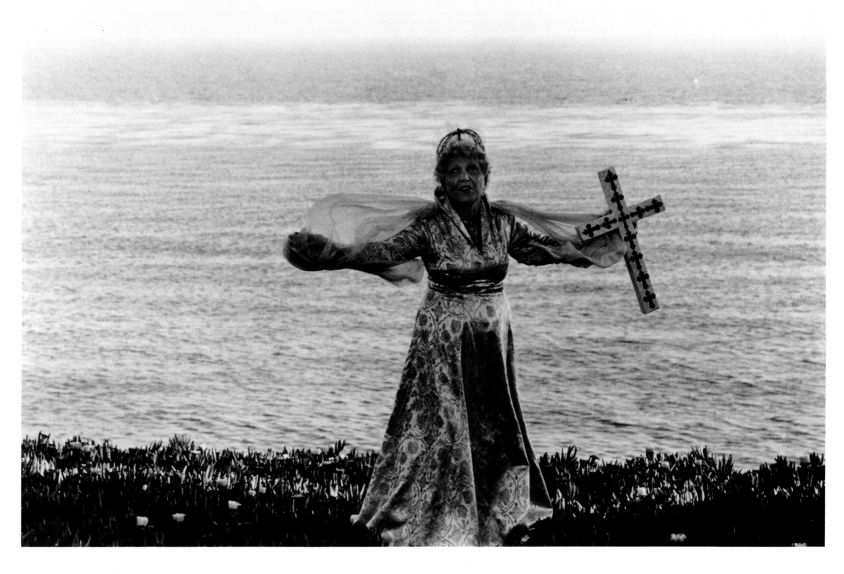

Diane Arbus
1923–1971
BISHOP BY THE SEA,
LOS ANGELES
1964
Gelatin silver print

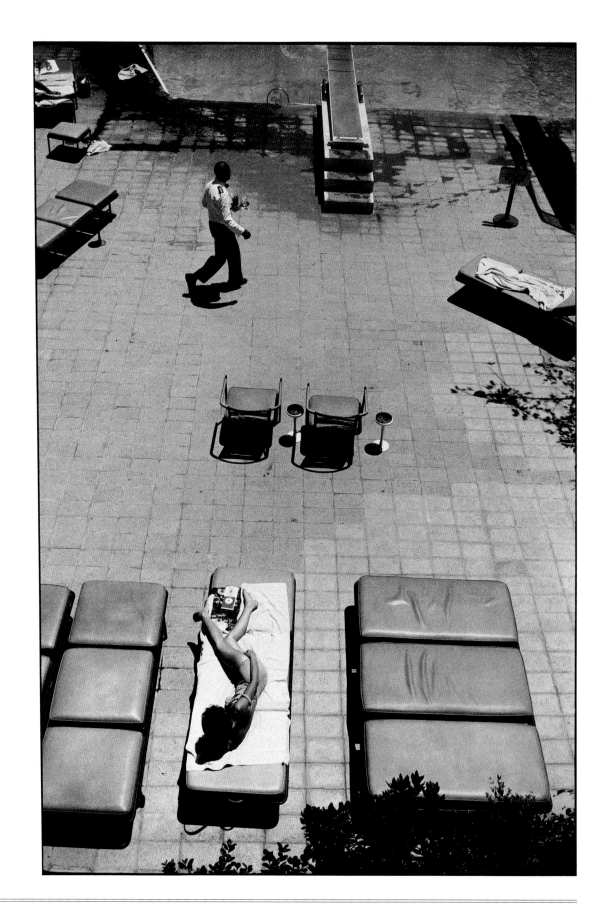

78

Garry Winogrand
1928–1984
UNTITLED
1964
Gelatin silver print

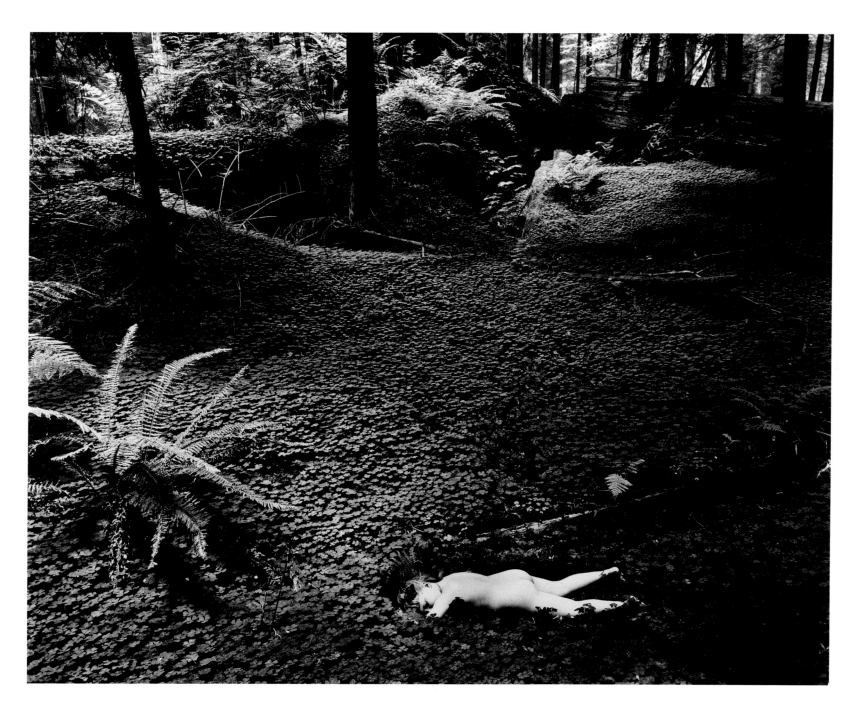

Wynn Bullock
1902–1975
CHILD IN THE FOREST
1951
Gelatin silver print

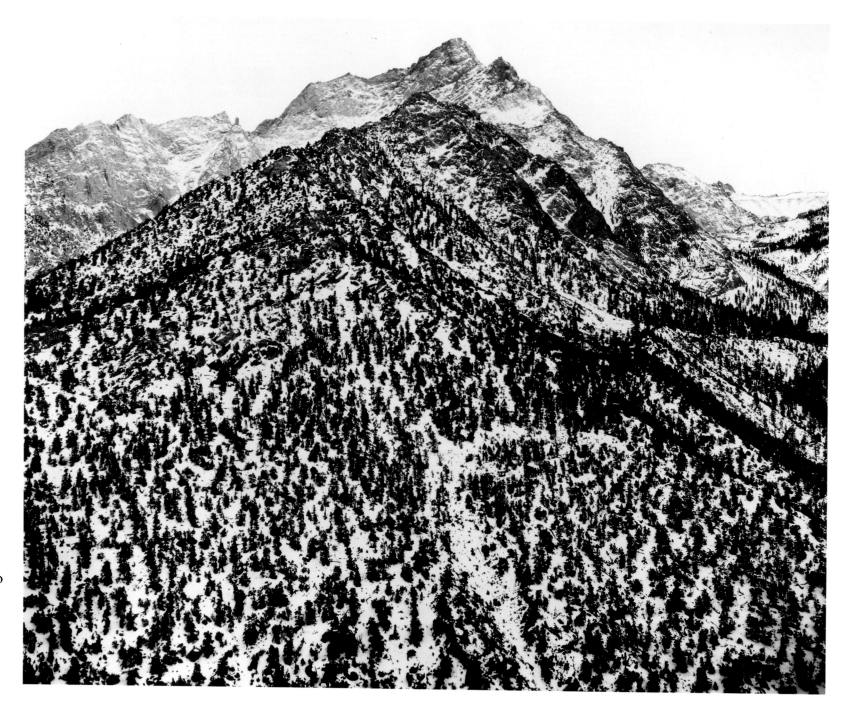

80

Ansel Adams
1902–1984
LONE PINE PEAK, THE
SIERRA NEVADA MOUNTAINS,
CALIFORNIA
c. 1960
Gelatin silver print

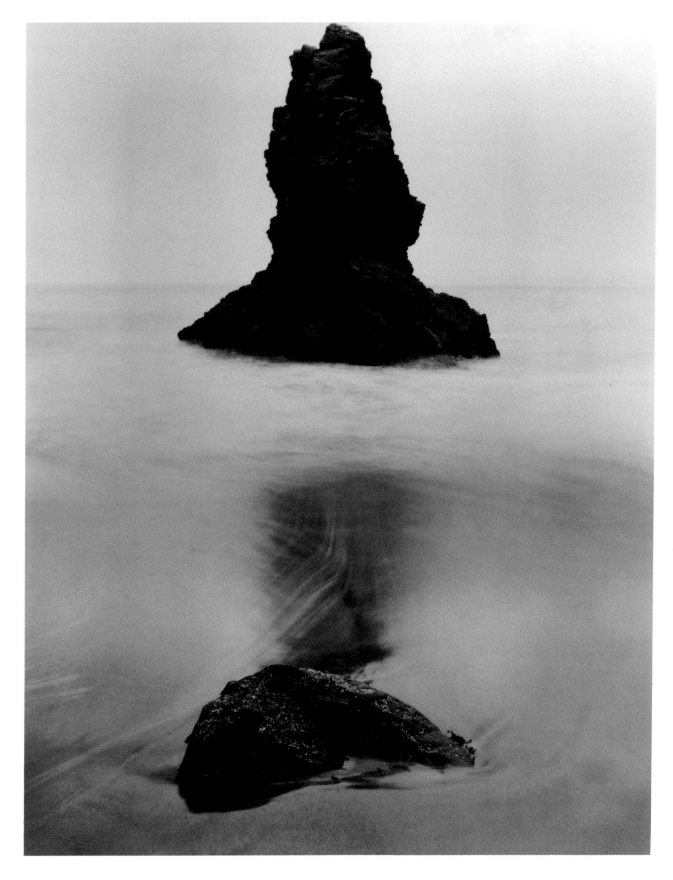

81

Don Worth
1924–
ROCKS AND SURF,
SAN FRANCISCO
1969
Gelatin silver print

82

Jack Fulton
1939–
CALIFORNIA FUNK
1971/1975
Cibachrome print

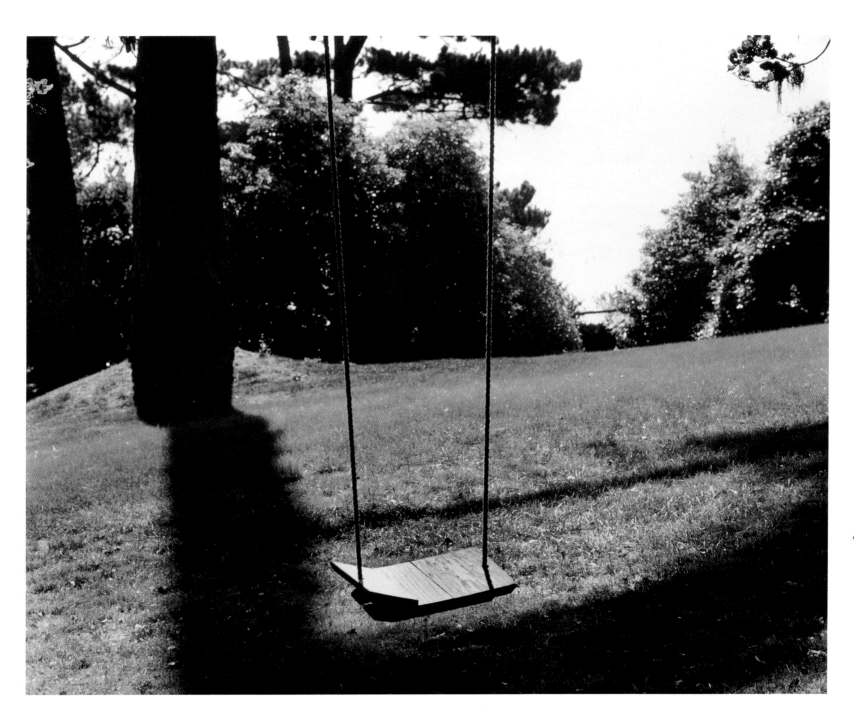

83

Shirley C. Burden
1908–1989
SWING
1965
Dye coupler print

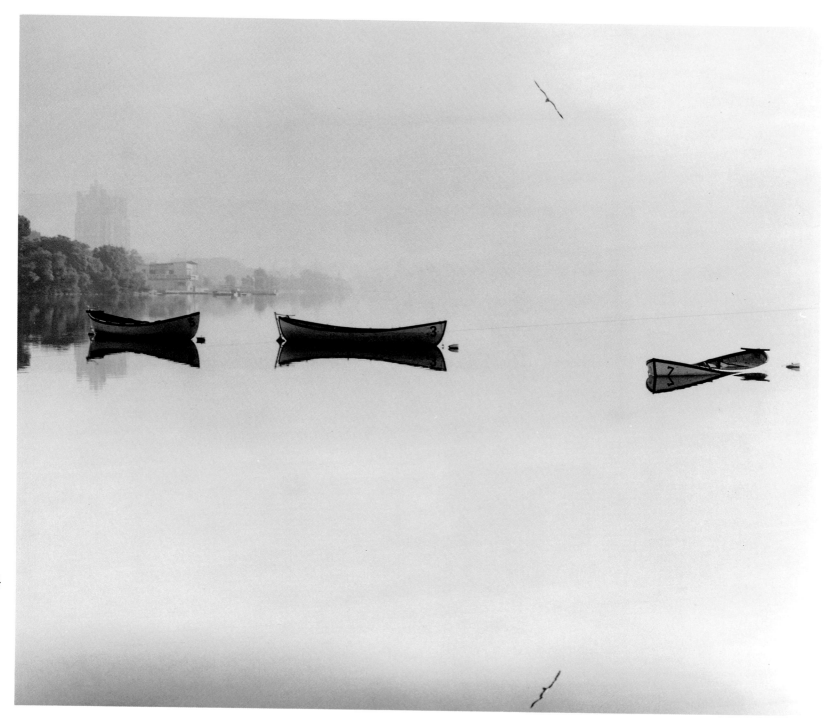

84

Jonathan Eubanks
1927–
BOATS ON THE LAKE
1966
Gelatin silver print

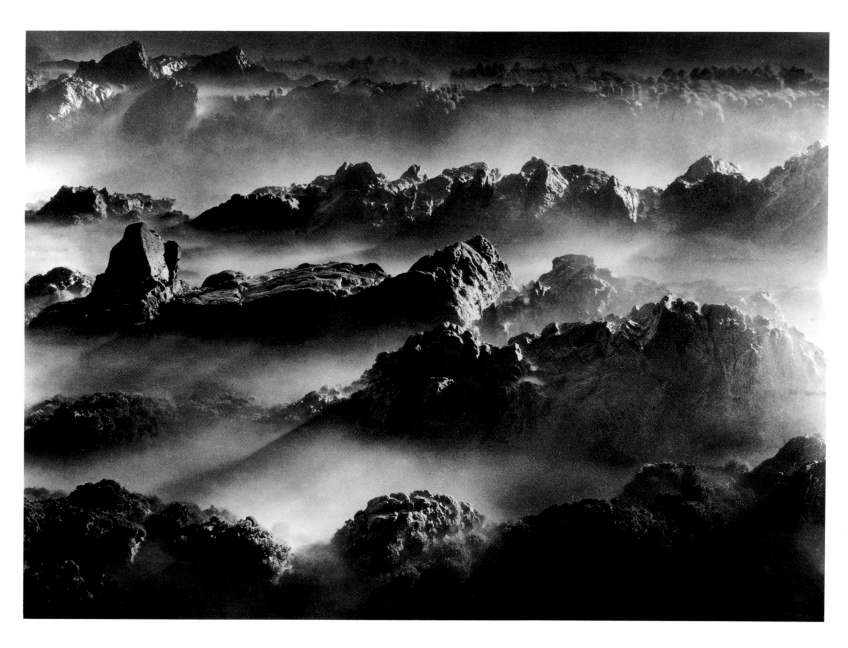

85

Wynn Bullock
1902–1975
OCEAN ROCKS
1966
Gelatin silver print

William Garnett
1916–
SAND DUNE, DEATH VALLEY,
CALIFORNIA
1967
Cibachrome print

86

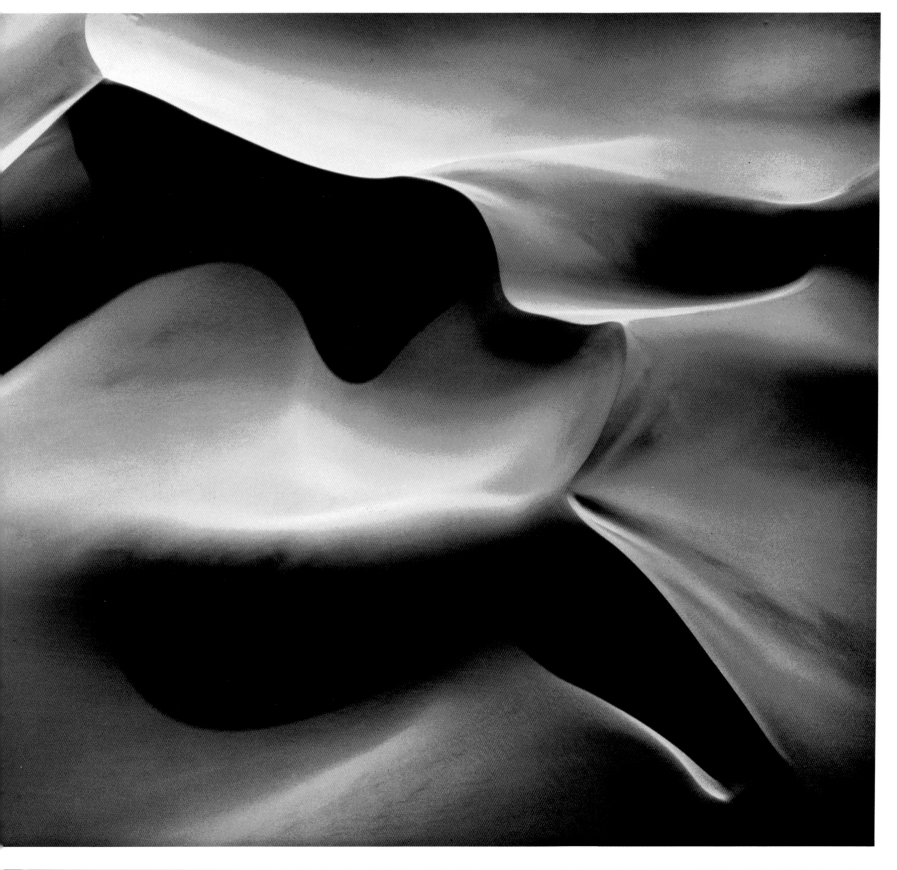

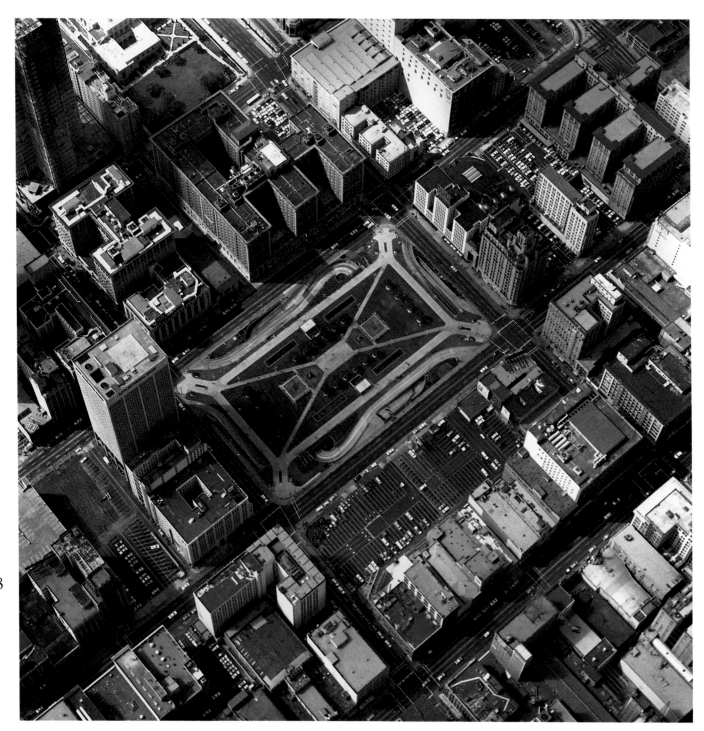

88

Edward Ruscha
1937–
THIRTYFOUR PARKING LOTS
IN LOS ANGELES
1967
Pershing Square, underground lot, 5th
and Hill, photographed by Art Alanis

89

Robert Frank
1924–
SAN FRANCISCO
1956/1977
Gelatin silver print

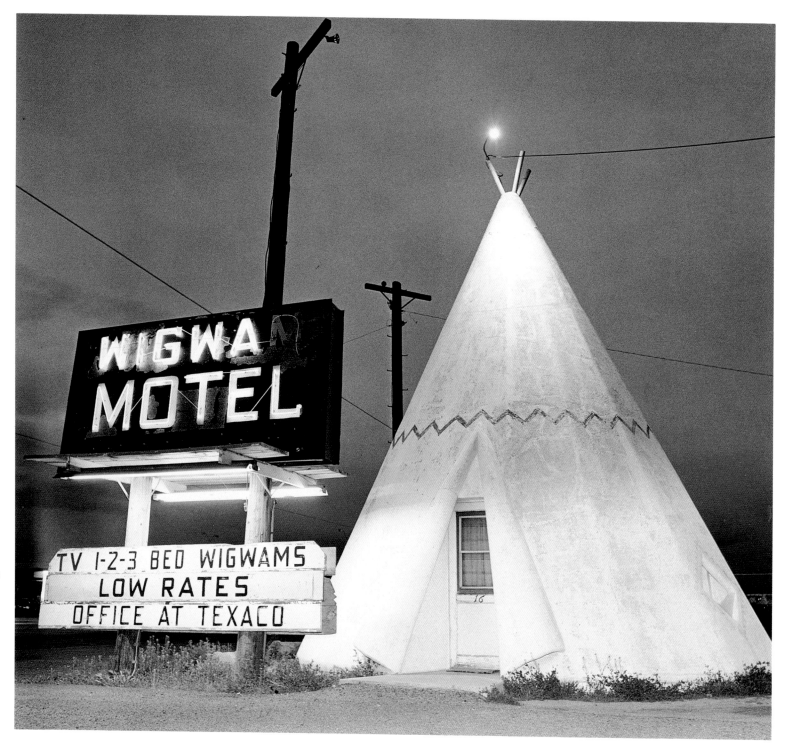

Steve Fitch
1949–
UNTITLED
1973
Toned print

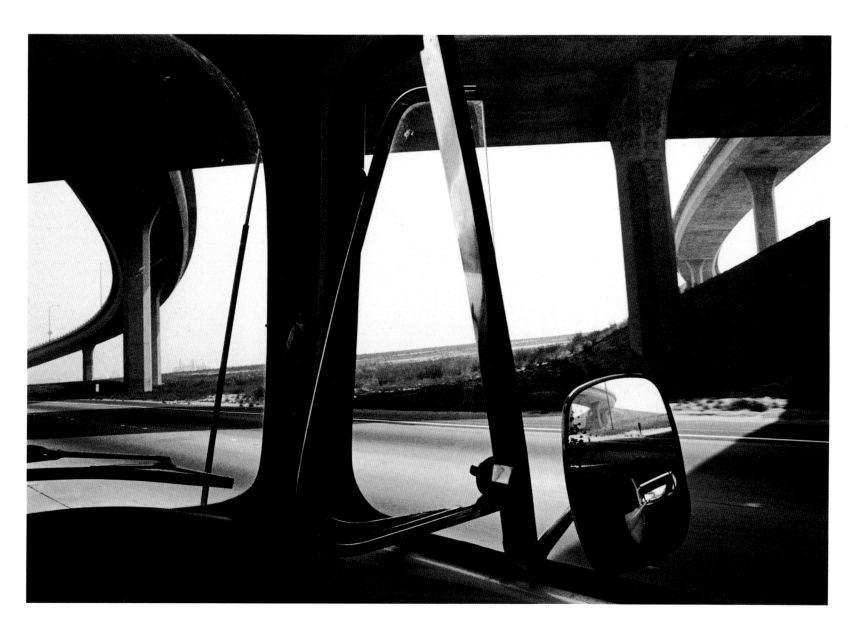

Roger Minick
1944–
FREEWAY INTERCHANGE
1976
Gelatin silver print, sepia-selenium toned

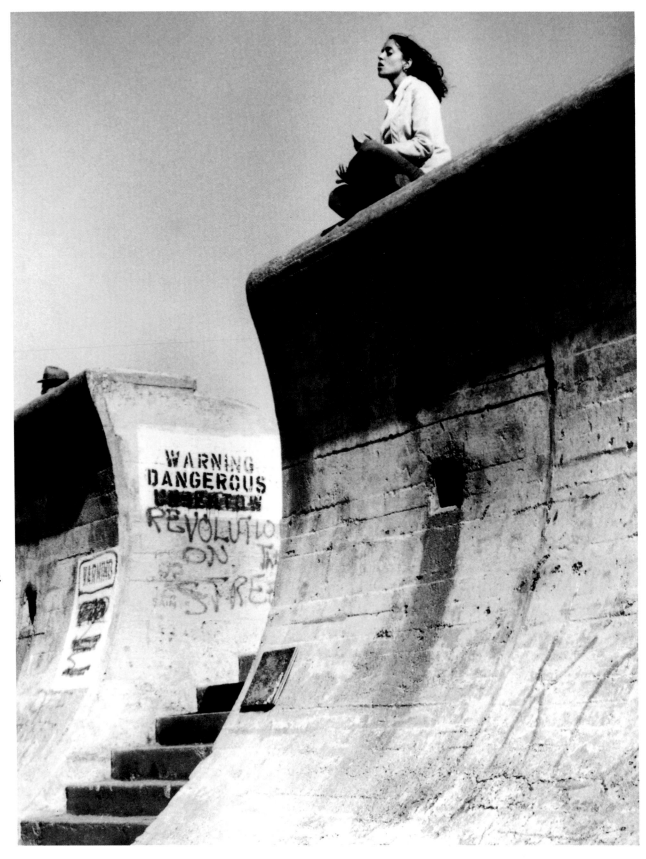

92

Bea Ullrich-Zuckerman
1907–1987
WARNING DANGEROUS
1973
Gelatin silver print

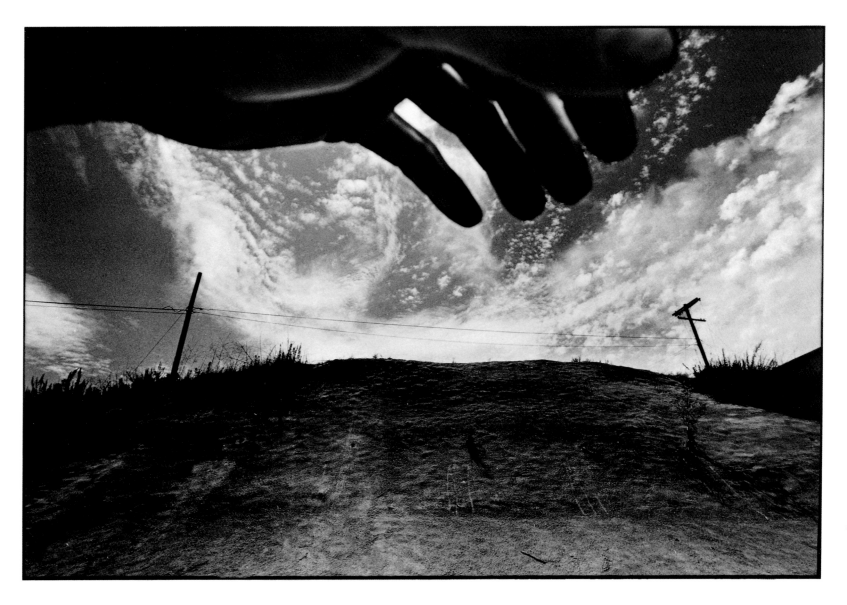

93

Victor Landweber
1943–
HAND SERIES, NO. 1
1973
Gelatin silver print

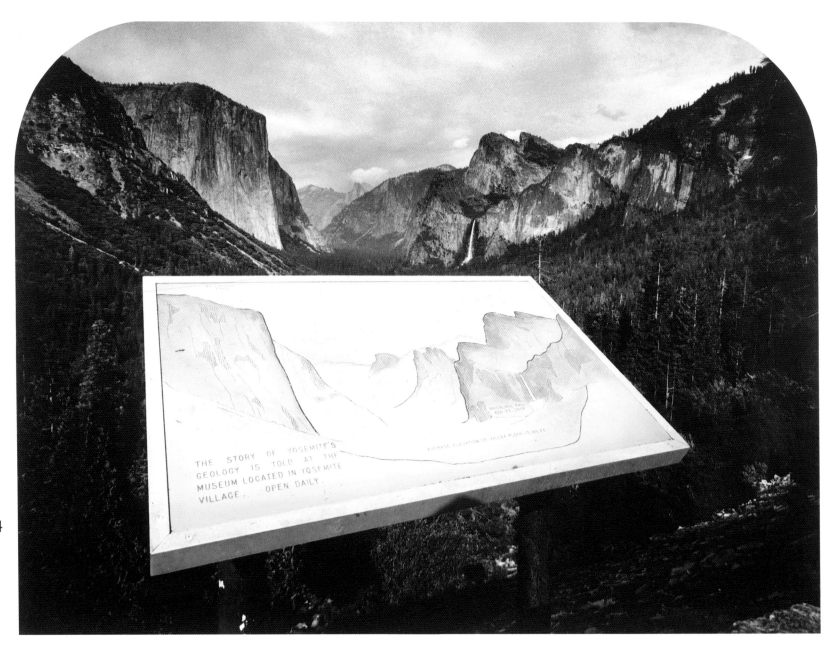

THE STORY OF YOSEMITE'S
GEOLOGY IS TOLD AT THE
MUSEUM LOCATED IN YOSEMITE
VILLAGE. OPEN DAILY.

94

Ted Orland
1941–
INSPIRATION POINT,
YOSEMITE
1975
Gelatin silver print, hand-tinted

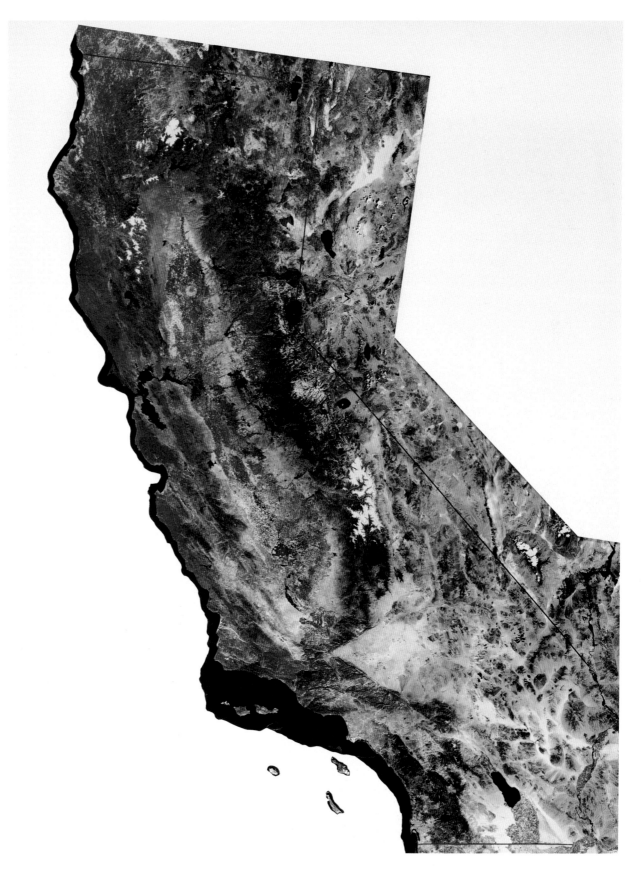

95

National Aeronautics and Space Administration
Established 1958
CALIFORNIA FROM
570 MILES UP
1972/1988
Chromogenic print from
computer-assisted montage of
42 radio-transmitted signals

96

Mark Citret
1949–
LONG SHADOWS
1971
Gelatin silver print

Joe Deal
1947–
SAN FERNANDO, CALIFORNIA
1978
Gelatin silver print, gold-toned

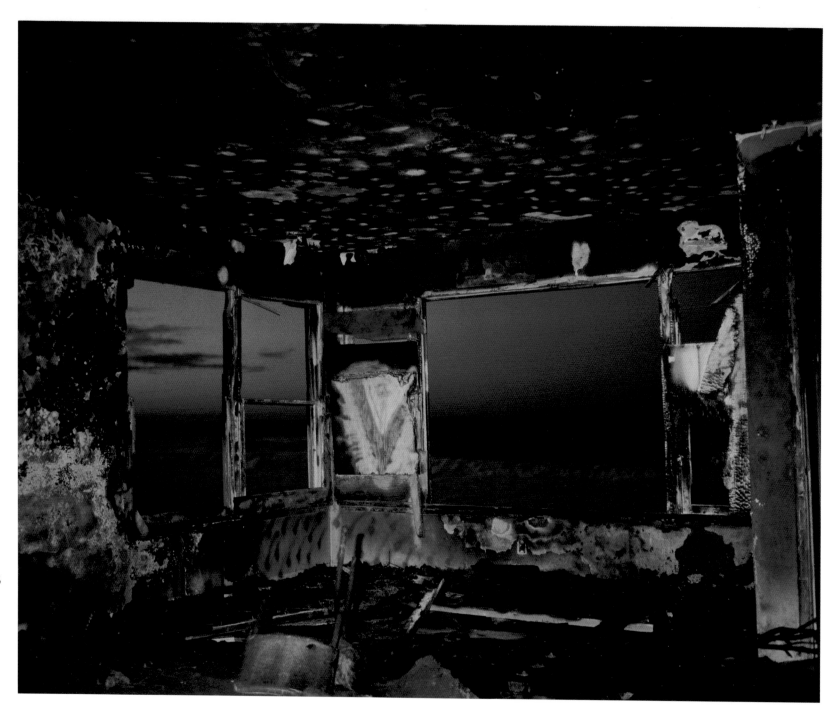

John Divola
1949–
UNTITLED
1978
Cibachrome print

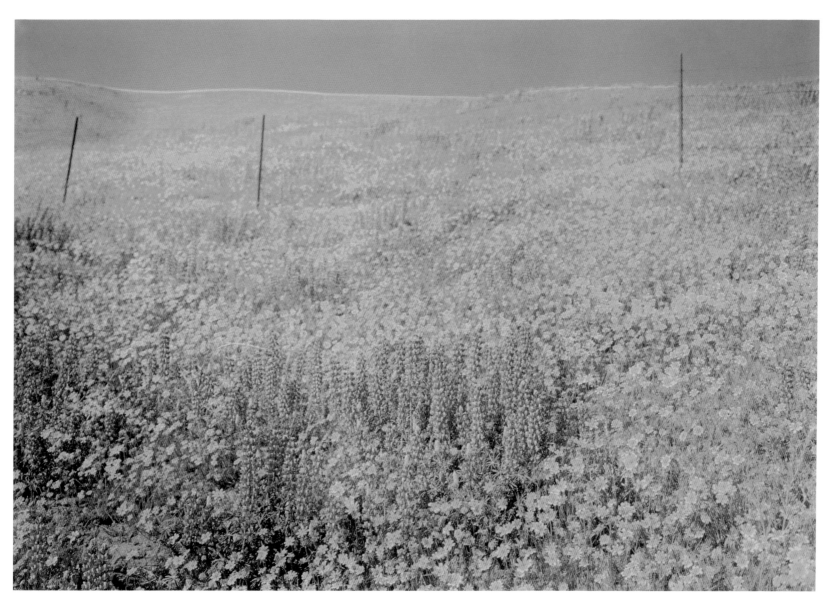

99

William Eggleston
1939–
UNTITLED
1974/1980
Dye transfer print

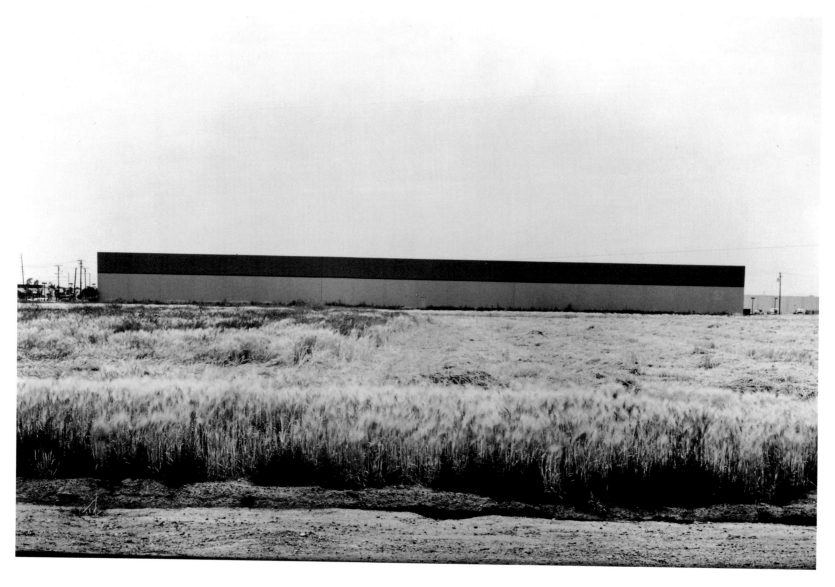

Lewis Baltz
1945–
EAST WALL, WESTERN CARPET
MILLS, 1231 WARNER, TUSTIN
1974
Gelatin silver print

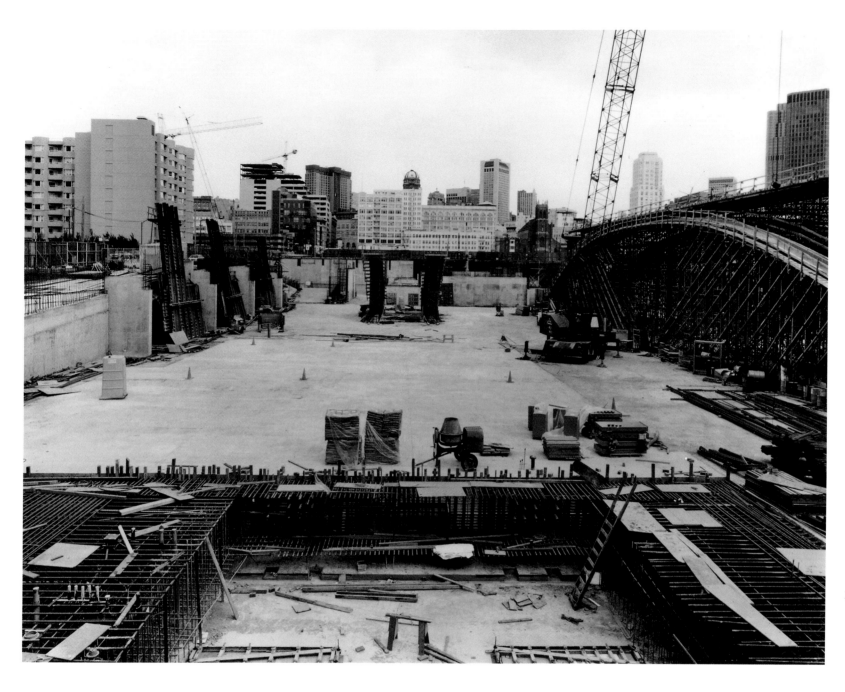

101

Catherine Wagner
1953–
NORTHWESTERN CORNER
WITH SAWHORSE AND CEMENT
MIXER, GEORGE MOSCONE
SITE, SAN FRANCISCO
1981
Gelatin silver print

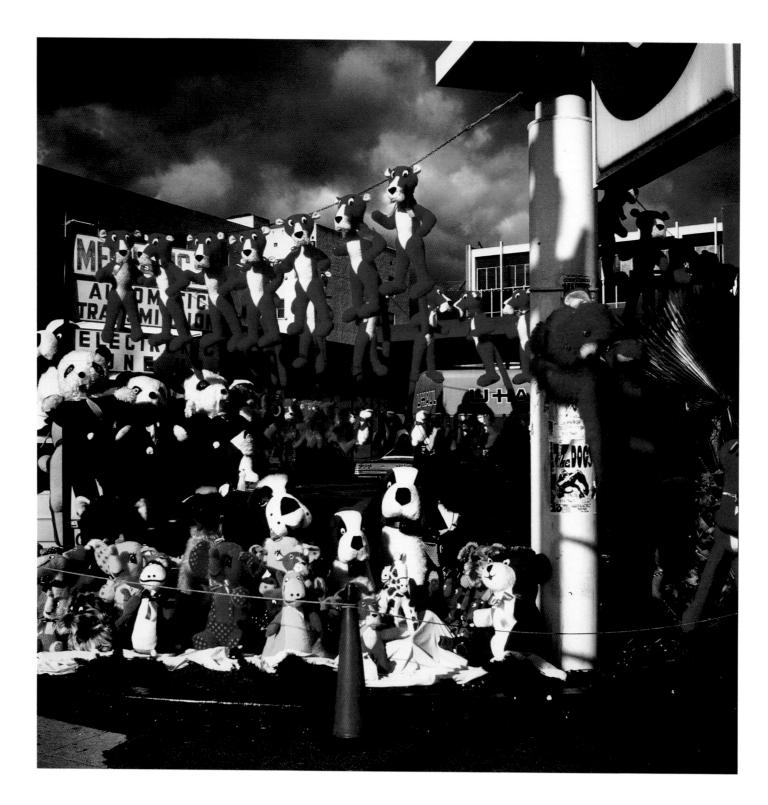

102

Kenneth McGowan
1940–1986
PINK PANTHERS
1978
Cibachrome print

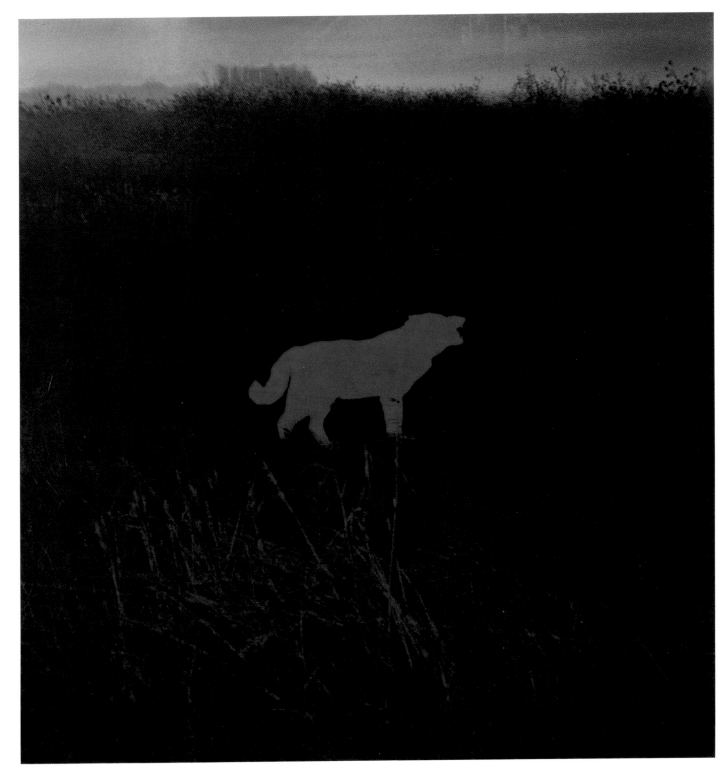

103

John Divola
1949–
WOLF
1983/1987
Dye transfer print

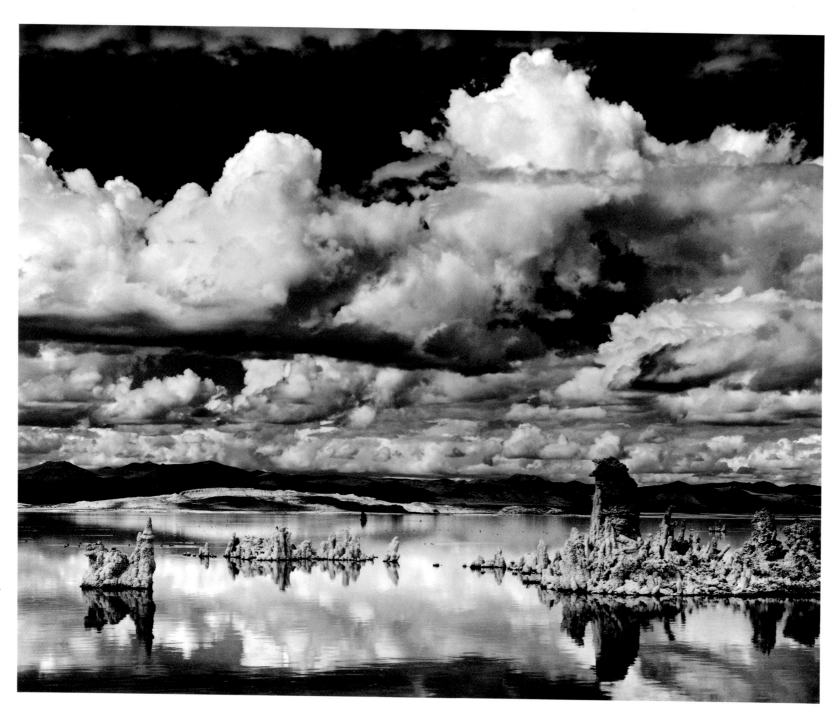

Joseph Holmes
1952–
CLOUDS OVER MONO LAKE
1975/1981
Gelatin silver print

105

Edmund Teske
1911–
MONO LAKE
1977
Duo-toned solarized print

CALIFORNIA

Jerry McMillan
1936–
CALIFORNIA
1978
Sulfide duo-toned print
from a black-and-white
photographic print

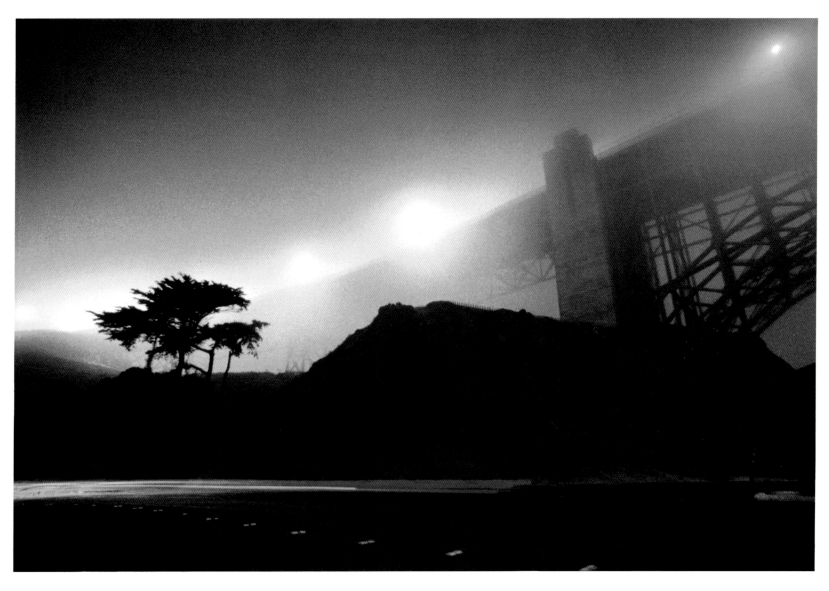

107

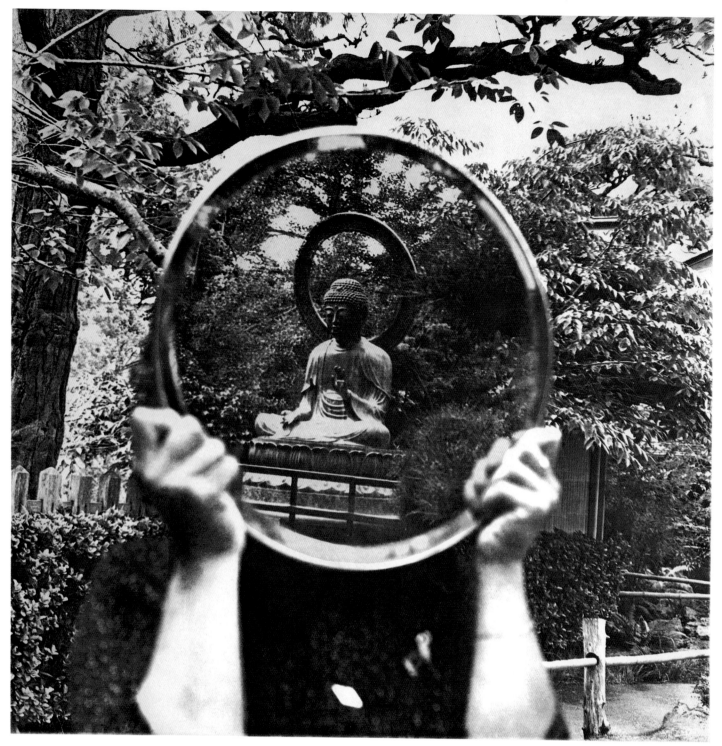

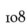 108

Iain Baxter
1936–
REFLECTED SAN FRANCISCO
BEAUTY SPOT — BUDDHA,
GOLDEN GATE PARK
1979
Photographic transfer etching

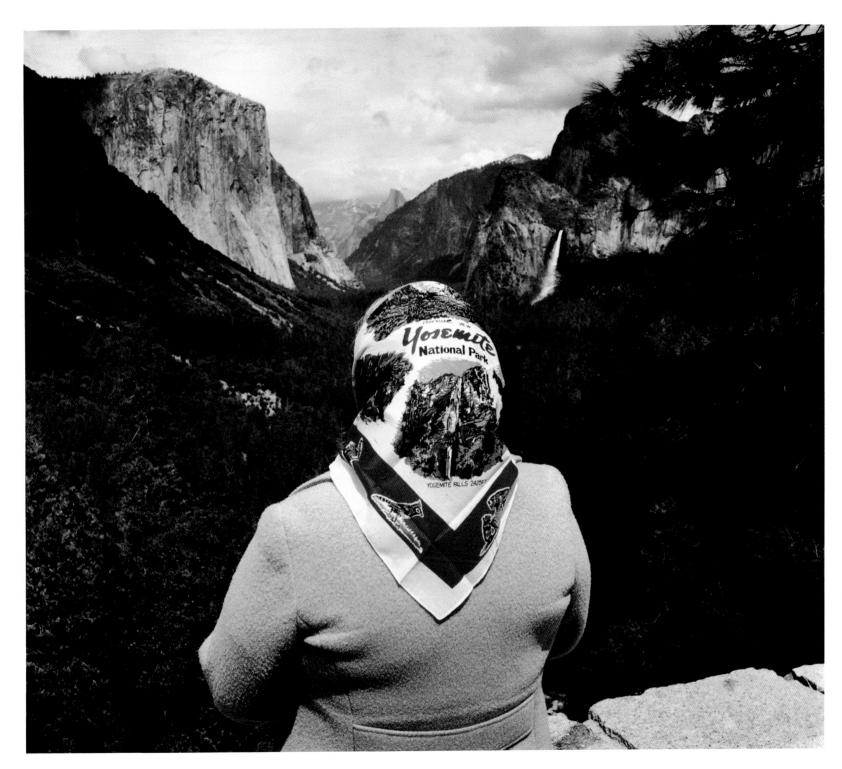

Roger Minick
1944–
YOSEMITE NATIONAL PARK
1980
Dye coupler print

Richard Misrach
1949–
UNTITLED
1979
Dye coupler print

Richard Misrach
1949–
WAITING, EDWARDS
AIR FORCE BASE
1983
Dye coupler print

Terry Husebye
1945–
UNTITLED
1980/1988
Dye coupler print

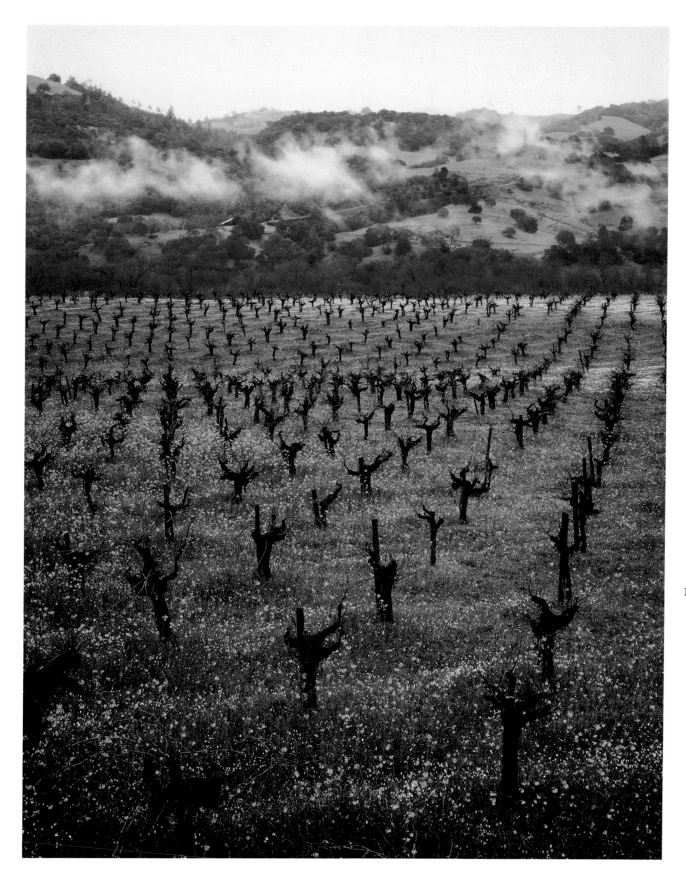

Morley Baer
1916–
VINEYARD, ASTI
1983
Cibachrome print

113

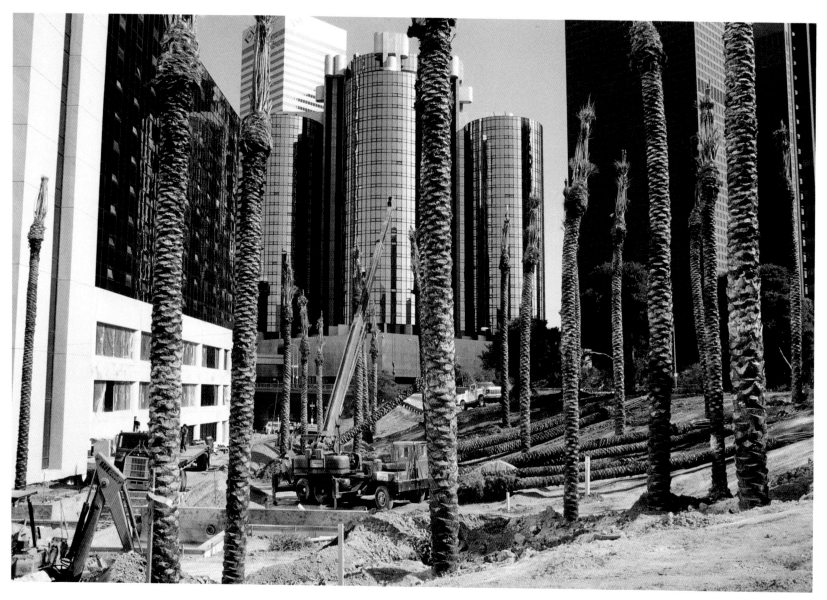

114

Douglas Muir
1940–
LANDSCAPING, SHERATON
GRANDE HOTEL, LOS ANGELES
1983
Dye coupler print

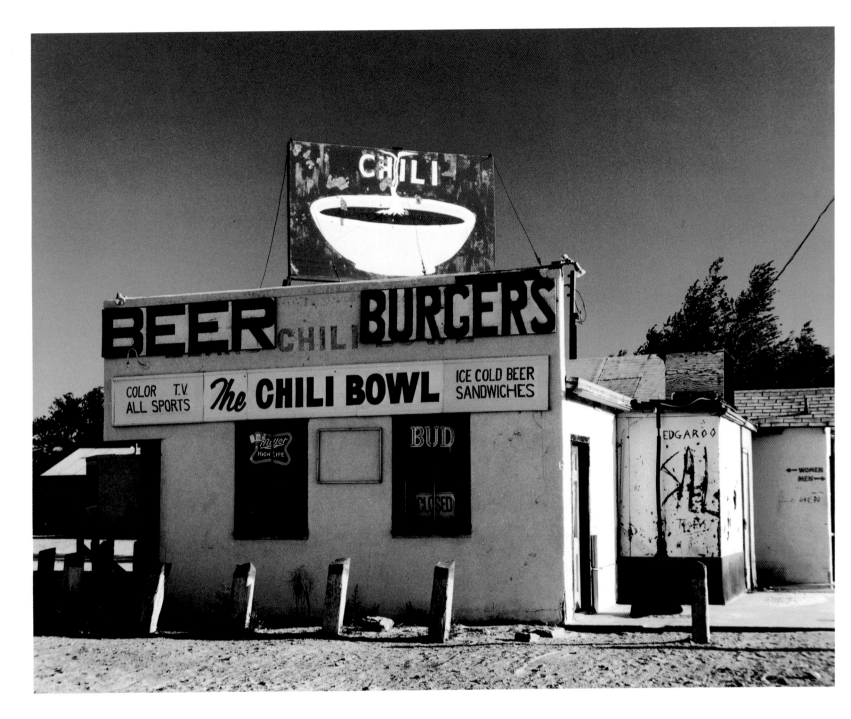

Arthur Evans
1934–
BARSTOW BAR
1981
Dye coupler print

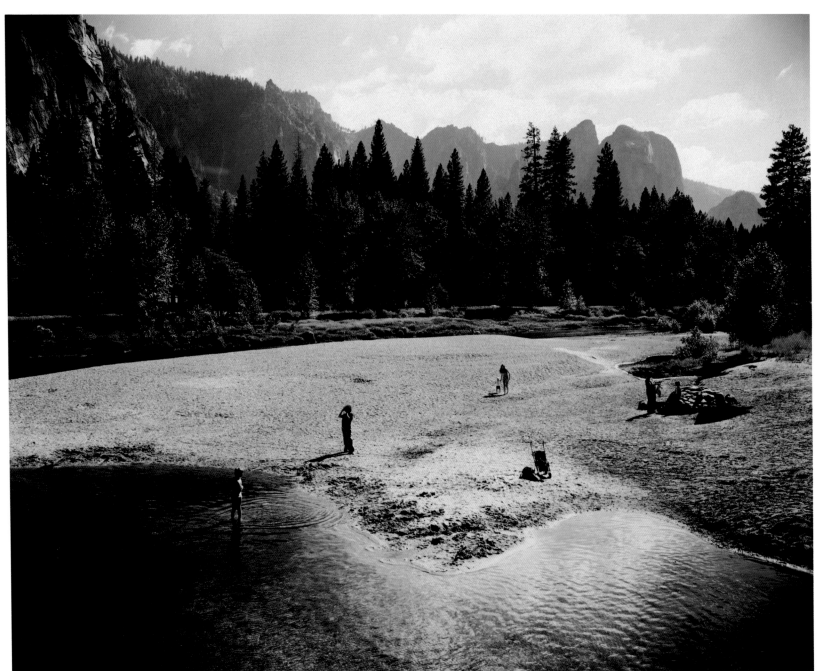

116

Stephen Shore
1947–
MERCED RIVER, YOSEMITE
NATIONAL PARK
1979
Dye coupler print

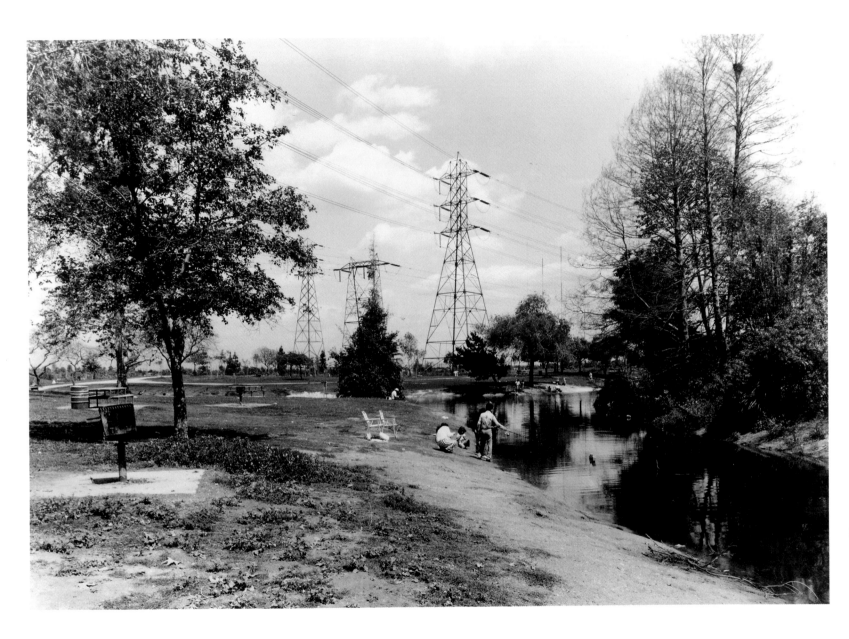

Anthony Hernandez
1947–
PUBLIC FISHING AREAS,
NO. 1, HERBERT C. LEGG LAKE
1979
Gelatin silver print

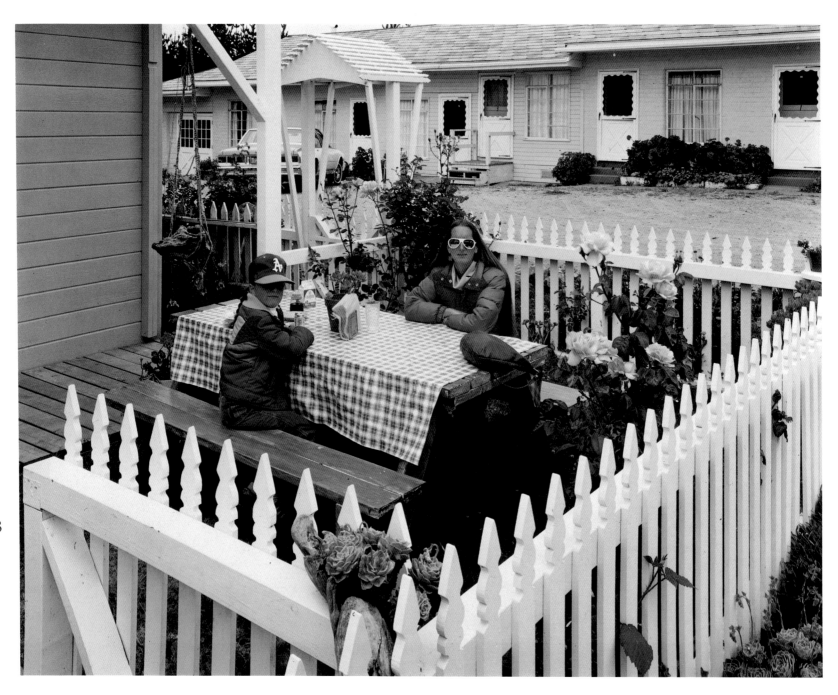

David Graham
1952–
MOTHER AND DAUGHTER,
NORTH OF SAN FRANCISCO
1981
Dye coupler print

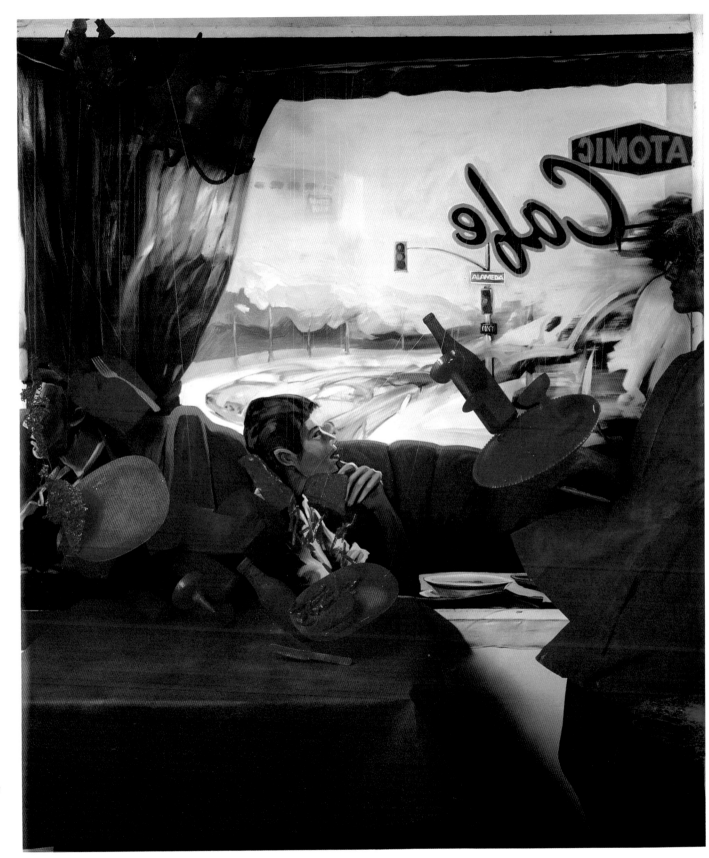

*Patrick Nagatani
and Andrée Tracey*
1945– / 1948–
ATOMIC CAFE
1983
Polaroid print

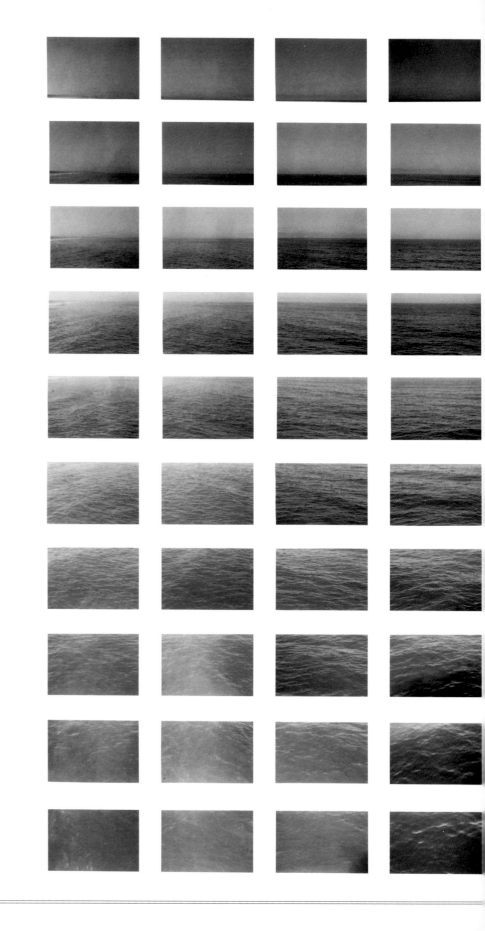

Robbert Flick
1939–
OCEAN I, SUMMER
1980
Gelatin silver print

120

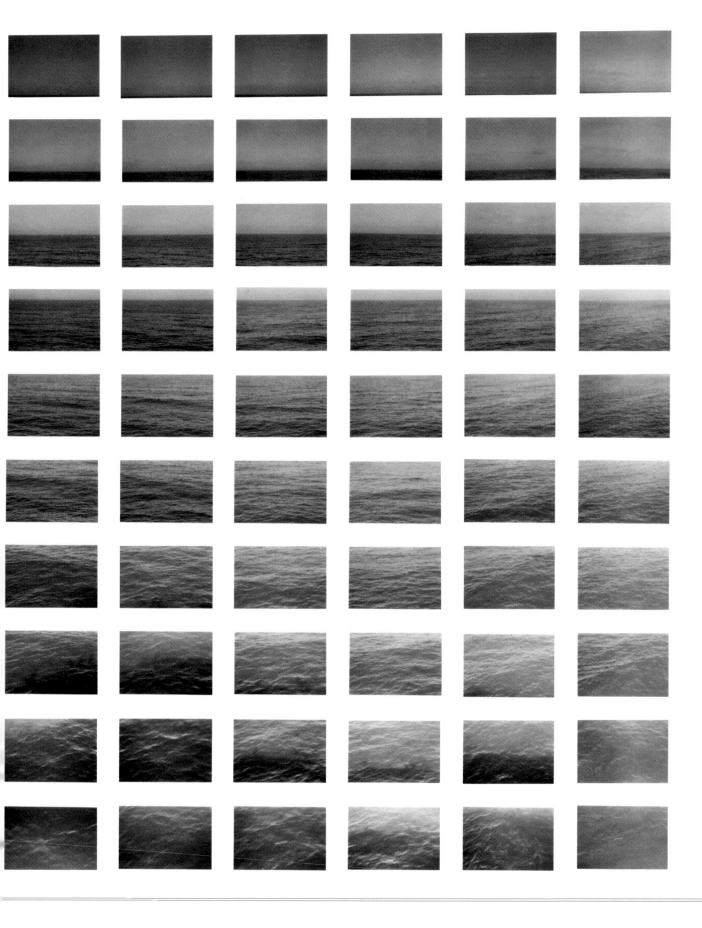

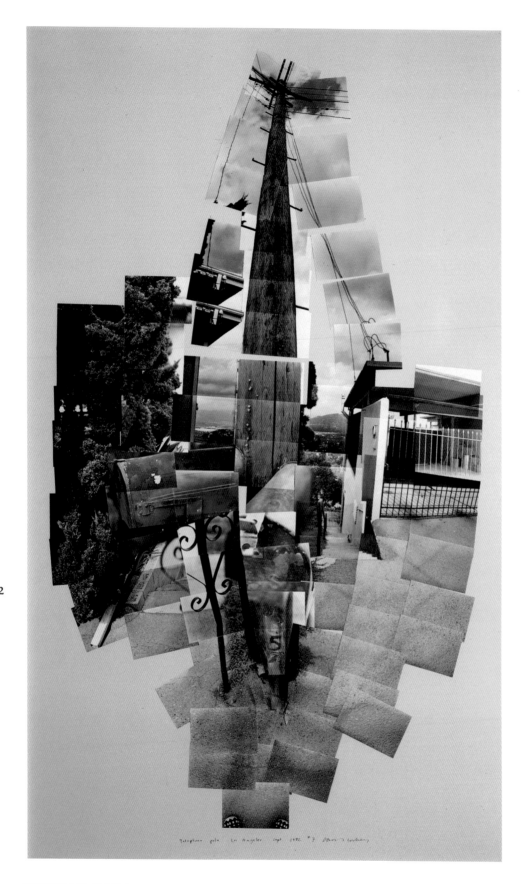

Telephone pole, Los Angeles, Sept. 1982 #7 David Hockney

David Hockney
1949–
TELEPHONE POLE, LOS
ANGELES, SEPTEMBER 1982,
NO. 7
1982
Instamatic color photographs mounted
on silk-screened board

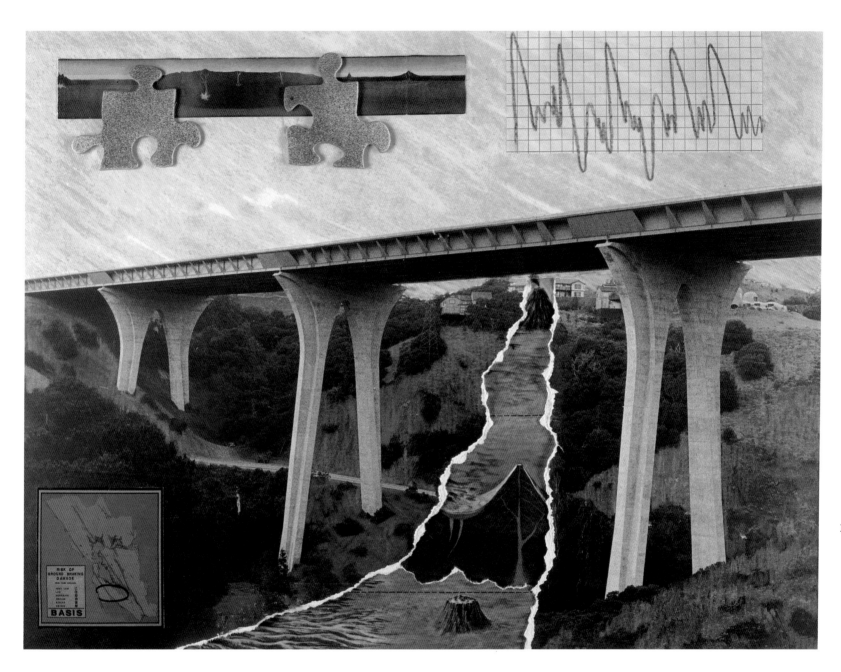

Brian D. Taylor
1954–
THE ROAD TO SAN ANDREAS
1982
Collage, gelatin silver print, hand-painted

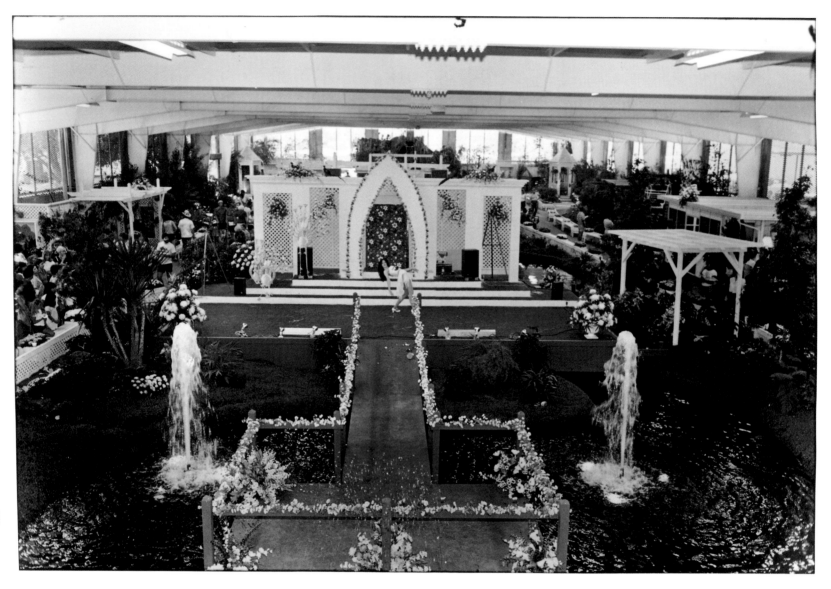

Bill Dane
1938–
ORANGE COUNTY, L.A.
EVENT AND FAIR
1982
Gelatin silver print

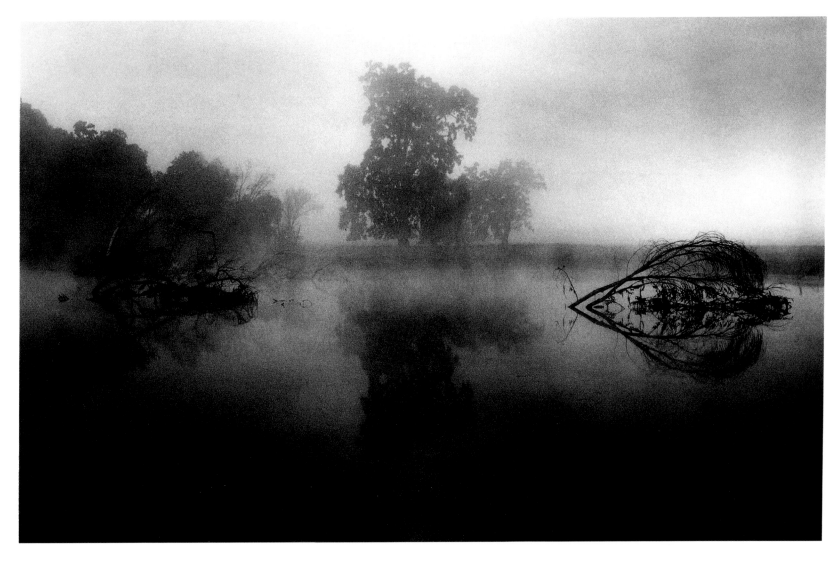

Michael Kenna
1953–
REFLECTION, BIG SUR,
CALIFORNIA, U.S.A.
1979/1980
Gelatin silver print, sepia-selenium toned

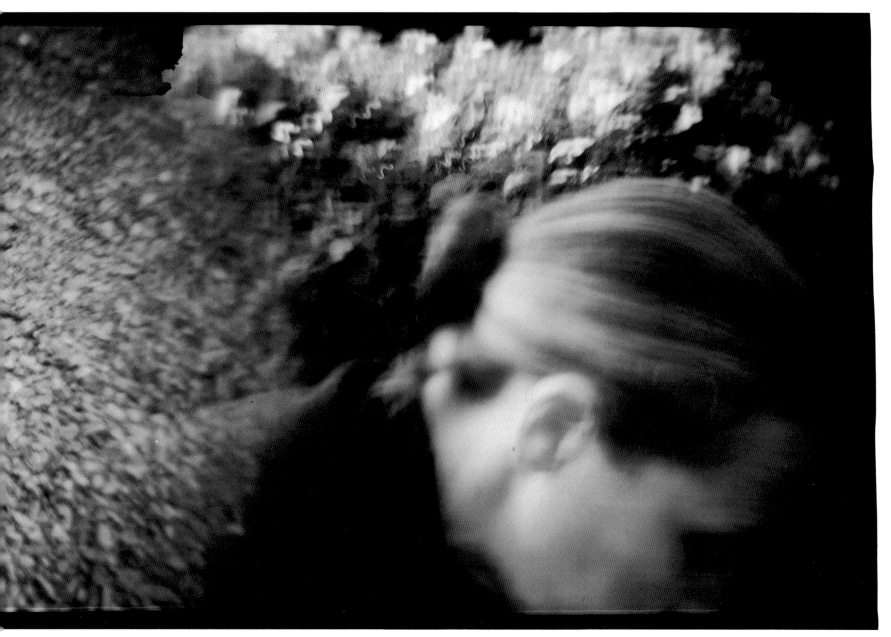

Sandra Haber
1956–
PORTRAIT OF BRYNA
1982
Dye coupler print

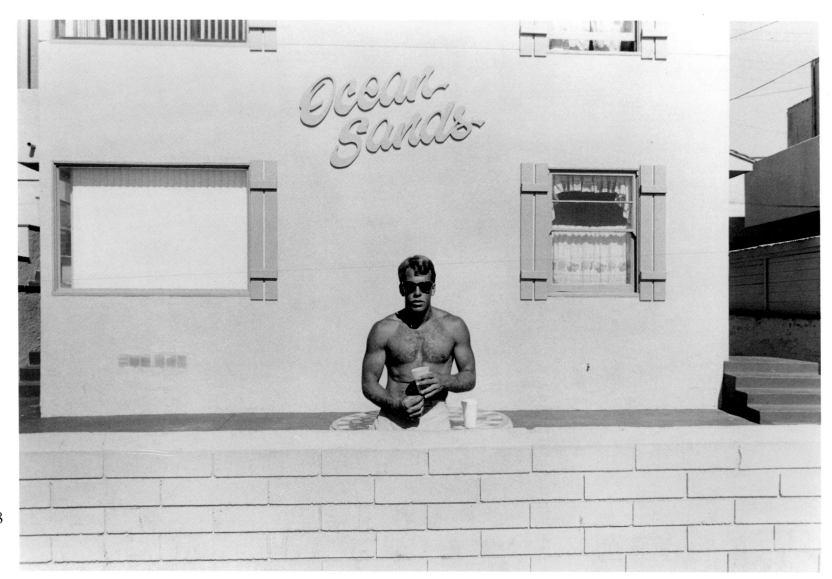

128

Henry Wessel
1942–
SOUTHERN CALIFORNIA
1985/1988
Gelatin silver print

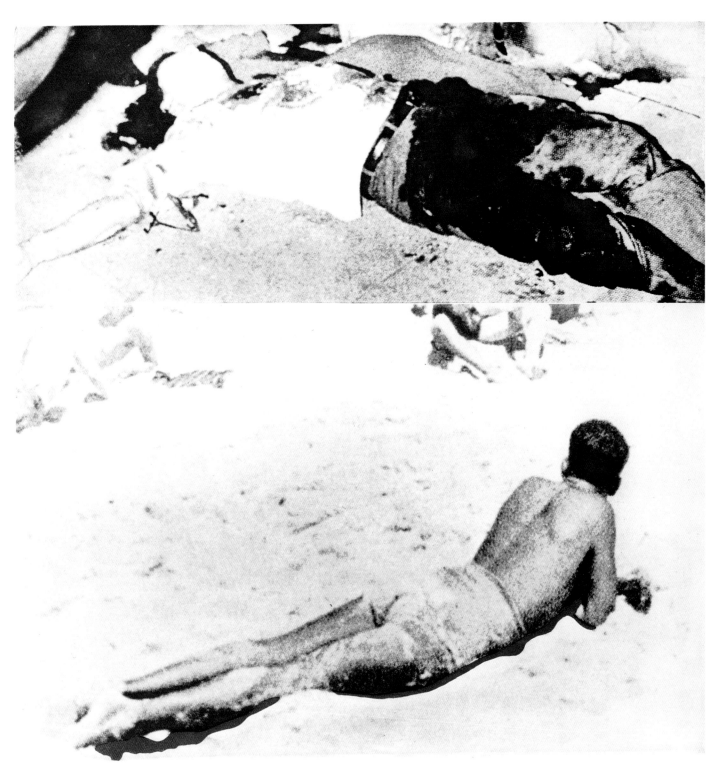

John Baldessari
1931–
TWO FIGURES/
ONE WITH SHADOW
1986
Photolithograph

130

John Gossage
1946–
WEST L.A.
1980
Gelatin silver print

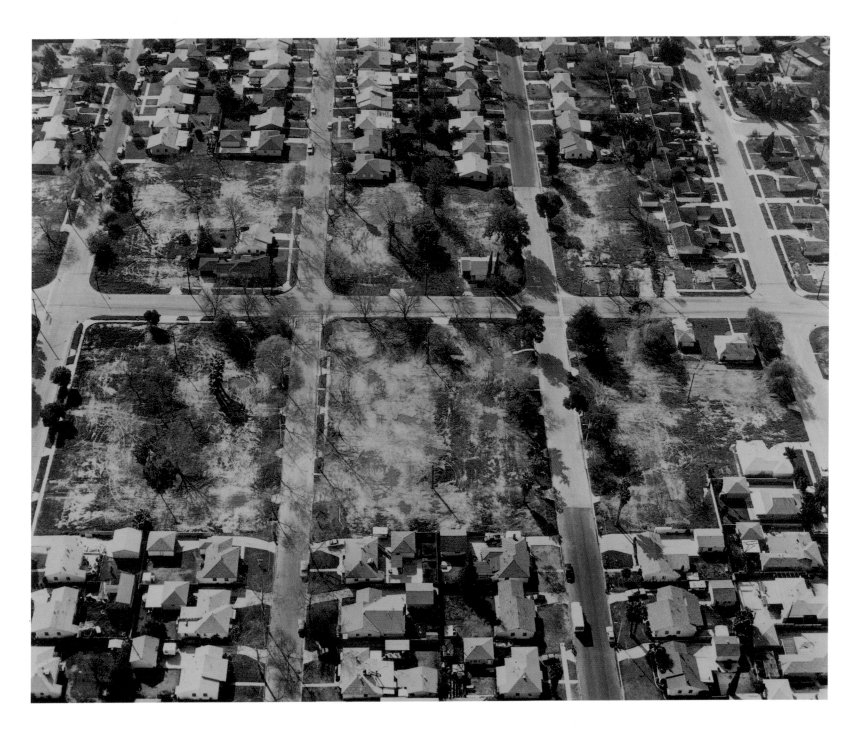

131

Jeffrey Gates
1949–
IN OUR PATH, NO. 4
1983/1985
Gelatin silver print

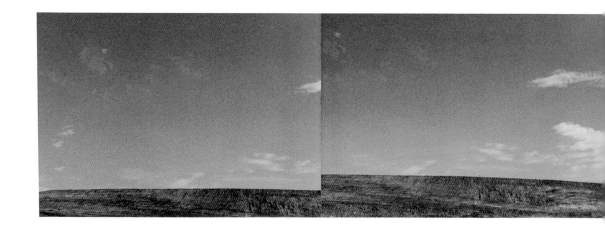

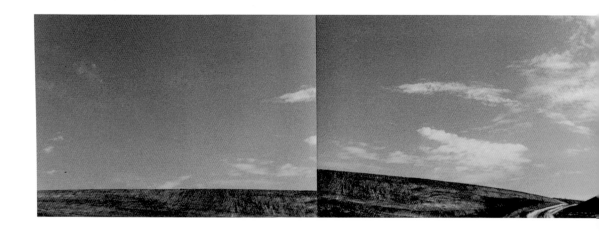

Laurie Brown
1937–
JOURNEY FORETOLD,
LAGUNA NIGUEL,
CALIFORNIA
1984
Cibachrome print

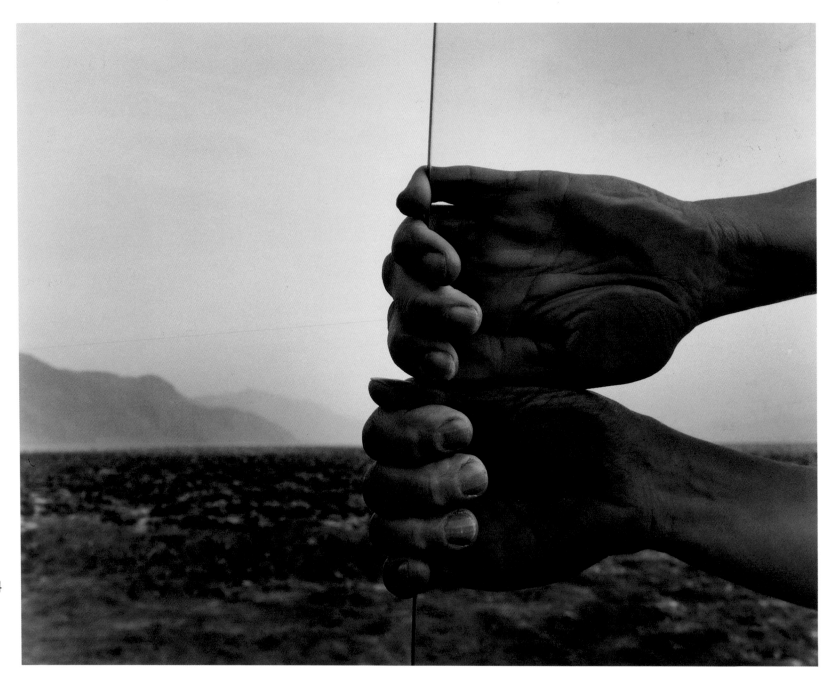

Judy Dater
1941–
MY HANDS, DEATH VALLEY
1980
Gelatin silver print

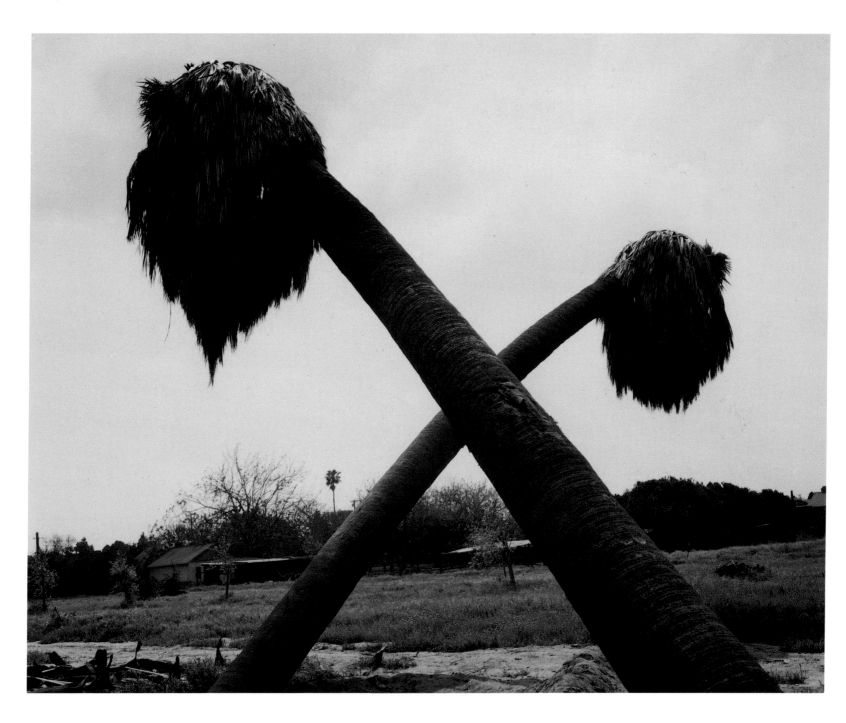

135

Robert Adams
1937–
DEAD PALMS, PARTIALLY
UPROOTED, ONTARIO,
CALIFORNIA
1983/1988
Gelatin silver print

136

Lawrie Brown
1949–
CALIFORNIA
1986
Polaroid print

137

Kenda North
1951–
PURPLE FLOWERS
1986
Dye transfer print

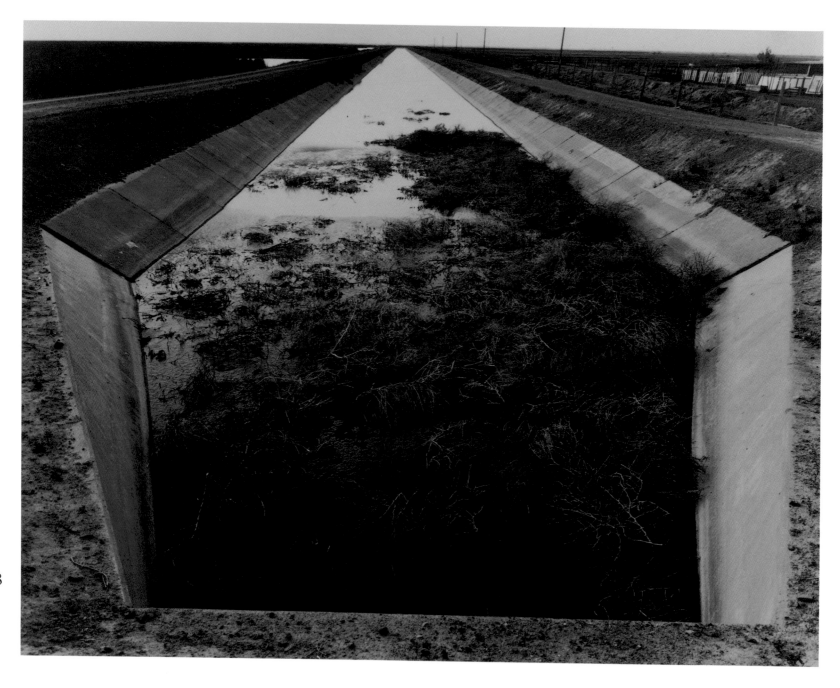

Robert Dawson
1950–
SAN LUIS DRAIN, KESTERSON
NATIONAL WILDLIFE REFUGE
1985
Gelatin silver print

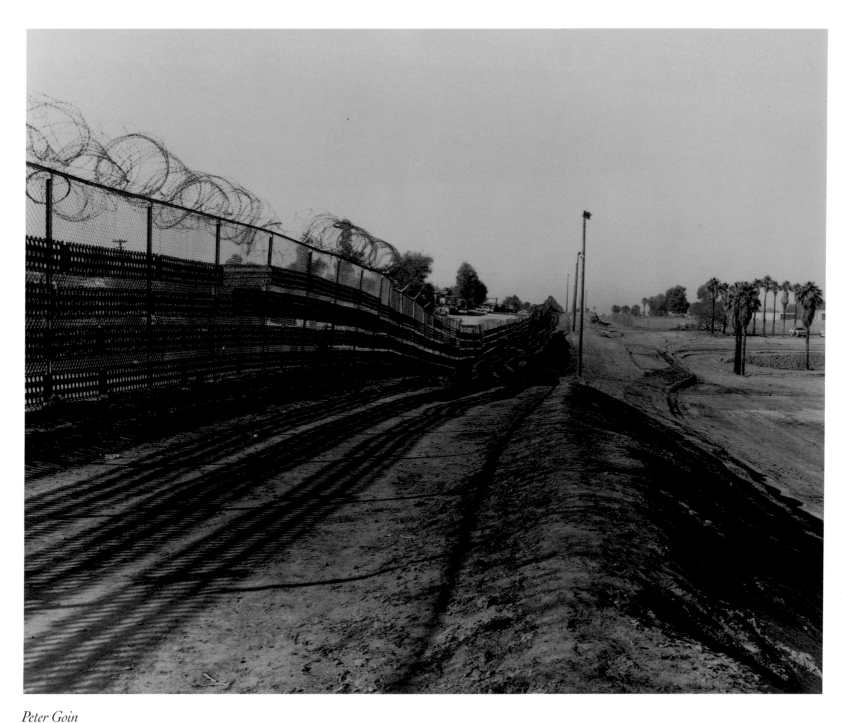

139

Peter Goin
1951–
IMPENETRABLE BORDER
FENCE CONSTRUCTED
BETWEEN CALEXICO AND
MEXICALI AND TOPPED WITH
BARBED CONCERTINA WIRE.
THE METAL SECTIONS ARE USED
TO REPAIR HOLES; CALLED
THE "TORTILLA CURTAIN."
1987
Gelatin silver print

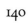

Nikolay Žurek
1936–
WIND FARM
1987
Dye transfer print

Scenes of Curiosity and Wonder

by THERESE HEYMAN

The state of California and the art of photography matured together. In the name of western geographic exploration, expanded settlement, and economic growth, the American government supported a series of great photographic surveys to picture and record the land. Beginning in the 1850s, American photographers traveled west and revealed to the nation California's missions, its Gold Rush, the building of its railroads, the discovery of its great natural wonders — Yosemite, Lake Tahoe, Big Trees — and the 1906 earthquake and fire in San Francisco. These events, and California's inherently photogenic nature, inspired early photographers, who made an enduring visual record of the state.

From the outset, despite inadequacies of their hastily assembled photographic studios and improvised darkroom wagons, these photographers of the West thought of their images as fine art. Although their photographs are clear and direct and mirrorlike, these pioneer photographers did more than simply depict the land around them. Their choice of perspective, their selection of subject, and their angle of view all convey feelings about this land. They soon came to see themselves as artists practicing the most American of the arts. And this art form, they claimed, was the one medium in which Americans clearly surpassed their European contemporaries.

Concern for this fine-art photography spurred many American improvements in cameras and lighting techniques. The products of these technical achievements were recognized abroad in frequent gold medal awards given to landscape photographers of the American West. At the Paris International Exposition of 1867–1868 the landscape views of C.L. Weed and Carleton Watkins were praised for their exceptional accomplishments; at the Vienna International Exhibition of 1873, Eadweard Muybridge received the Medal of Progress for landscape. By the 1870s these western photographers had made artistic and technical innovations that permitted land surveyors to examine photographs for evidence of mineral deposits. Muybridge put his photographic abilities to work solving problems caused by the early orthochromatic glass plate negative, which could not register clouds in the bright western sky. He printed a sandwich of negatives that included the sky of South America with mountains of California. Photography began as — and remains — a significantly California undertaking.

Photographers who could perfect their talents and work without studio amenities in the wilderness could depend on buyers for their landscapes. American travelers and explorers were willing to purchase views of the West, while others sought out scenes to satisfy their abundant curiosity; they were pleased to support photography and collect images of the landscape. The pioneer's awe before depictions of its grandeur, the adventurer's dream of the riches it concealed, corresponded

to the need of photographers to find a subject that could demonstrate their skills. Images of a new land challenged these skills and drew a nationwide audience. At the same time, photography in the Far West satisfied the mining interests of Leland Stanford and the plans of railroad builders such as William Jewett, who needed a means of communication that could verify claims and encourage investors.

The makers of California photography, as well as the market, became involved in portraits, genre studies, and studio still lifes, but their special attraction to the wealth of natural resources and natural wonders caused them to concentrate on landscape pictures. Subsequent improvements in paper prints and the building and adoption of a large view camera with a so-called mammoth plate — 18 by 22 inches — enabled landscape photographers of the 1870s and 1880s to convey the majesty and scale of western scenery in their images. By combining sequences of images into panoramas, landscape photographers could achieve sweeping scenes while preserving minute detail.

As the number and availability of these photographs increased, they became a convenient source for many painted views, done by studio painters; the art of photography, practiced under duress far from civilization, came to serve and support the art of the atelier. Many painters of western scenes subscribed

to the series of published mammoth-plate photographs issued by Thomas Houseworth and others in the late 1860s and 1870s. Thomas Hill, the prolific painter of dramatic views of Yosemite and the Sierra, consulted these landscape photographs in determining his compositions. And often photographers, such as A.J. Russell, had been trained in painting and were familiar with the best means to signify important landmarks.

When publishers realized the extraordinary interest in the Sierra on the part of painters, travelers, and adventurers, Houseworth, and later Taber, and Bradley and Rulofson, issued multiple replications of prints at attractive prices. Artist supply shops, optical equipment stores, and the front rooms of galleries were filled with tempting selections of exceptional views in many standard formats, from the small cabinet size to the sumptuous mammoth plate. Albums and portfolios, sets and series were issued, as well as mounted images for tipping into printed books and onto U.S. Survey reports. These images were often imprinted with title, sponsor, and publisher, but only later with the name of the photographer.

While the give-and-take between photographer and painter may have begun with photographers providing the detailed visual information, there were frequent shifts of aesthetic perception. In the early 1890s, Pictorialist photographers sought painterly effects in landscapes to emphasize those subjective artistic qualities generated from within; such scenes often included ambiguous,

fleetingly seen figures, and tonal, shadowy, and romantic images. Despite the inherent credibility of the photographic image, these photographs acknowledged their status as fabricated vision. Hand-painted misty scenes of the 1915 Panama-Pacific International Exposition, a fantasy in itself, as well as commanding clouds snatched from South America skies and imposed over California mountains (Muybridge's method of combining negatives enjoyed a long-lived popularity) were a few of the many surreal visual events.

Picturing California is a highly selective gathering of 114 images from the many thousands in the collection. While no single exhibition can adequately convey the range of beauty and accomplishment of the landscape photographers of California, this choice attempts to balance the rare and the masterful, the everyday and the spectacular.

The landscape images in this exhibition reflect the extraordinary metamorphosis Edward Weston described: "Through photography I would represent the significance of facts, so they are transformed from things seen to things known"— conditions enhanced by the act of photographing, which lends importance to a subject by the very act of selection.

Certain attitudes toward the magnificent California landscape have persisted into the present — in the search

for sites of unexpected beauty, in the reach toward still-unspoiled places. Along with writers, conservationists, and natural scientists, photographers Roger Minick and Richard Misrach have passionate feelings concerning contemporary uses of the land. Their ironic visions gain power from iconoclastic contrasts, and bring ridicule and satire into the California photographer's armament. Some photographers comment humorously, showing that the grand view of an unspoiled mountain is but one, and often the rarest, landscape we encounter; others demonstrate that many of us now only see our landscape reflected in the car's side-view mirror. Artistic protests visualize irony in their use of opposites: souvenir tee-shirts are photographed in the landscape they advertise; cramped space and seductive colors splash vandalized building windows; garish night light transforms a famous bridge.

Photographs of the land have one curious aspect in common: power. Landscape photographs seem to transmit and partake of the magisterial quality of western lands that tower above humankind with a serene indifference. The striking quality is that these images seem to swallow man and ideas whole; subject matter threatens art every time. The train crossing the desert, the campers crossing the mountain, and the man beside the Big Tree may all come and go, but they cannot take the landscape of the West with them.

142

Photography Checklist

All photographs are in the collection of The Oakland Museum. Entries in the checklist are arranged in chronological order. The date following the title refers to the date of the negative while a second date preceded by a slash refers to the date of the print. Portfolio and book titles are followed by a publication date. The artist's spelling of the title has been retained. Information in brackets following untitled works is descriptive and provided by the museum. An asterisk (*) denotes works attributed to an artist. Dimensions indicate image size, and height precedes width.

William Shew (1820–1903)
UNTITLED [Shew's Daguerrian Saloon], 1851
Daguerreotype, quarter plate
4⅜ × 5½ in.
Gift of Mr. and Mrs. Willard M. Nott and Paul Schuster Taylor

Unidentified photographer
PANORAMIC VIEW OF SAN FRANCISCO, 1853
Six half-plate daguerreotypes mounted in vintage frame
16½ × 59½ in.
Gift of Minna McGauley Stoddard

Carleton E. Watkins (1829–1916)
SENTINEL ROCK, FRONT VIEW 3270 FEET, YOSEMITE VALLEY, c. 1861
Albumen print, mammoth plate
16¾ × 20½ in.
Gift of the Cowell Memorial Foundation

Carleton E. Watkins (1829–1916)
THE LOWER YOSEMITE FALL, 418 FEET, c. 1861
Albumen print, mammoth plate
20⅝ × 15⅝ in.
Gift of the Women's Board, Oakland Museum Association

Carleton E. Watkins (1829–1916)
NEW ALMADEN QUICKSILVER MINE, 1863
Albumen print
15 × 20⅝ in.
Gift by exchange through the Oakland Public Library

*Charles Leander Weed** (1828–1903)
THE YOSEMITE FALL, 2634 FEET HIGH, c. 1863
Published by Thomas Houseworth & Co.
Albumen print
20¼ × 15¾ in.
Gift of Mr. and Mrs. Rodney Holt

Andrew Joseph Russell (1830–1902)
DONNER LAKE, SIERRA NEVADA MOUNTAINS, SNOW SHED TUNNELS IN FOREGROUND, 1869/1988
Solar print made from Russell's original imperial glass-plate negative
11 × 14 in.
The Andrew J. Russell Glass-Plate Negative Collection, The Oakland Museum History Department

Unidentified photographer
MOTHER OF THE FOREST, 305 FEET HIGH,
 MAMMOTH GROVE, c. 1870
Published by Thomas Houseworth & Co.
Albumen print
12¾ × 10 in.
Museum Donors Acquisition Fund

Timothy O'Sullivan (c. 1840–1882)
ALPINE LAKE IN THE SIERRA NEVADA,
 CALIFORNIA, c. 1871
Published by the War Department, Corps
 of Engineers, U.S. Army
Albumen print
16 × 20 in.
Timken Fund Purchase

Eadweard Muybridge (1830–1904)
PI-WI-ACK, VALLEY OF THE YOSEMITE, 1872
Published by Bradley & Rulofson
Albumen print, mammoth plate
16¾ × 21½ in.
Gift of Robert B. Honeyman, Jr.

Eadweard Muybridge (1830–1904)
MARIPOSA GROVE OF MAMMOTH TREES, 1872
Published by Bradley & Rulofson
Albumen print, mammoth plate
16¾ × 21½ in.
Gift of Robert B. Honeyman, Jr.

Eadweard Muybridge (1830–1904)
CAP OF LIBERTY, VALLEY OF THE YOSEMITE,
 1872
Published by Bradley & Rulofson
Albumen print, mammoth plate
16¾ × 21½ in.
Gift of Robert B. Honeyman, Jr.

Eadweard Muybridge (1830–1904)
FALLS OF THE YOSEMITE, FROM GLACIER
 ROCK, 1872
Published by Bradley & Rulofson
Albumen print, mammoth plate
21½ × 16¾ in.
Gift of Robert B. Honeyman, Jr.

George Fiske (1835–1918)
HALF DOME (5000 FEET) AND GLACIER
 POINT (3200 FEET), YOSEMITE VALLEY,
 c. 1880
Albumen print
10 × 7 in.
The Oakland Museum Founders Fund

Arnold Genthe* (1869–1942)
UNTITLED [Plant Nursery, Chinatown,
 San Francisco], between 1895 and 1911
Gelatin silver print
7¼ × 9½ in.
Anonymous donor

Unidentified photographer
UNTITLED [Ocean Beach, with Cliff House
 and Sutro Mansion, San Francisco],
 c. 1900
Toned cabinet photograph
4½ × 9½ in.
Gift of Mrs. Agnes Drummond

Willard Worden (1868–1946)
RUINED CITY, EAST FROM NOB HILL, 1906
Gelatin silver print
7½ × 9¼ in.
Gift of Dr. Robert Shimshak

Oscar Maurer (1871–1965)
HOMELESS, 1906/1950
Gelatin silver print
5⅞ × 13 in.
Museum Income Purchase Fund

Herbert W. Gleason (1855–1937)
JEFFREY PINES ON SENTINEL DOME,
 YOSEMITE, c. 1908
Palladium print
10 × 12 in.
The Shirley Burden Fund for Photography

Anne Brigman (1869–1950)
THE LIMPID POOL, 1909
Gelatin silver print
9⅝ × 6⅛ in.
Gift of Mr. and Mrs. Willard M. Nott

Andrew Barnaby McKinne (1881–1966)
YOSEMITE SCENES, SIERRA CLUB, c. 1910
From an album containing 38 prints
Toned print
11⅛ × 14⅝ in.
Gift of Mrs. Andrew Barnaby McKinne

Anne Brigman (1869–1950)
THE STORM TREE, 1911
Gelatin silver print
7½ × 9¼ in.
Gift of Mr. and Mrs. Willard M. Nott

Willard Worden (1873–1946)
UNTITLED [Palace of Fine Arts, Panama-
 Pacific International Exposition], 1915
Gelatin silver print, hand-tinted
7½ × 9¾ in.
Gift of Mr. and Mrs. Willard M. Nott

John Paul Edwards (1884–1969)
THE STROLLERS, CARMEL BEACH,
 MONTEREY COAST, 1918
Gelatin silver print
11½ × 9½ in.
Gift of Mrs. John Paul Edwards

Alvin Langdon Coburn (1882–1936)
CALIFORNIA, YOSEMITE FALLS, c. 1920
Platinum print
12 × 10 in.
The Shirley Burden Fund for Photography

Karl Struss (1886–1981)
IN THE SOUTHLAND, MT. BALDY,
 CALIFORNIA, c. 1921
Gum platinum print
13 × 10 in.
Gift of Mr. and Mrs. Willard M. Nott

Johan Hagemeyer (1884–1962)
PEDESTRIANS, 1922
Gelatin silver print
9¾ × 7⅝ in.
Gift of Mrs. Mabel T. Bjorge in memory
 of Mrs. Horton Denny

Edward Sheriff Curtis (1869–1952)
BEFORE THE WHITE MAN CAME, PALM
 CAÑON, 1924
Published by Suffolk Engraving Co.
Photogravure
15½ × 11½ in.
The Oakland Museum History
 Department

Edward Sheriff Curtis (1869–1952)
SIGNAL FIRE TO THE MOUNTAIN GOD,
 c. 1925
Orotone on glass
14 × 11 in.
Dudley P. Bell Fund Purchase

Alice Burr (1883–1968)
UNTITLED [Palm Trees], c. 1925
Bromoil transfer print
9¾ × 9¼ in.
Gift of Mr. and Mrs. Anthony R. White

Henry A. Hussey (1887–1957)
BONE YARD, 1926
Bromoil print
9½ × 7¼ in.
Gift of Mrs. Henry A. Hussey

Ansel Adams (1902–1984)
BLACK ROCK PASS, THE HIGH SIERRA, PACK
 TRAINS IN SNOW, c. 1927
Gelatin silver print
5¾ × 7⅞ in.
Gift of Francis P. Farquhar

Imogen Cunningham (1883–1976)
BANANA PLANT, c. 1924
Gelatin silver print
12¼ × 9½ in.
Gift of the Reva and David Logan
 Foundation

Imogen Cunningham (1883–1976)
LEAF PATTERN, c. 1924
Gelatin silver print
11¾ × 9⅜ in.
Gift of the Reva and David Logan
 Foundation

William Edward Dassonville (1879–1957)
UNTITLED [Landscape with Barn], c. 1929
Charcoal Black silver print
11 × 14 in.
Gift of Mrs. Henry A. Hussey

Edward Weston (1886–1958)
ROCK EROSION, 1932/1934
Gelatin silver print
7½ × 9⅜ in.
Gift of Brett Weston

Dorothea Lange (1895–1965)
FILIPINOS CUTTING LETTUCE, SALINAS
 VALLEY, 1935/1988
From An American Exodus, 1939
Gelatin silver print
11 × 14 in.
The Dorothea Lange Collection, gift of
 Paul Schuster Taylor

Peter Stackpole (1913–)
WAITING ON CATWALK, 1935
Gelatin silver print
6¼ × 9⅜ in.
The Oakland Museum Founders Fund

John Gutmann (1905–)
FIRST DRIVE-IN THEATRE, 1935/1988
Gelatin silver print
11 × 14 in.
The Shirley Burden Fund for Photography

Paul Outerbridge (1896–1958)
UNTITLED [Nude in Tree], 1936
Tri-color carbro print
17 × 13¼ in.
The Shirley Burden Fund for Photography

Edward Weston (1886–1958)
MODOC LAVA FLATS, 1937
Gelatin silver print
7½ × 9½ in.
Museum Donors Acquisition Fund

Alma Lavenson (1897–)
CHURCH, VALLECITO, 1938
Gelatin silver print
7¾ × 7¾ in.
Gift of the artist

Man Ray (1890–1976)
UNTITLED [The Pony Express Museum],
 c. 1940
Gelatin silver print
10 × 7¾ in.
The Shirley Burden Fund for Photography

Dorothea Lange (1895–1965)
MANZANAR RELOCATION CENTER, 1942
Gelatin silver print
11 × 14 in.
The Dorothea Lange Collection, gift of
 Paul Schuster Taylor

Ansel Adams (1902–1984)
WINTER SUNRISE, THE SIERRA NEVADA,
 FROM LONE PINE, CALIFORNIA, 1944
Gelatin silver print
13½ × 19¼ in.
Gift of the Art Guild, Oakland
 Museum Association

Ansel Adams (1902–1984)
MOUNT WILLIAMSON, THE SIERRA NEVADA,
 FROM MANZANAR, CALIFORNIA, 1945
Gelatin silver print
15⅛ × 18¾ in.
Dudley P. Bell Fund Purchase

Edward Weston (1886–1958)
NORTH DOME, POINT LOBOS, 1946
From the Edward Weston Fiftieth
 Anniversary Portfolio, 1951
Gelatin silver print
16 × 14 in.
Gift of the Concours d'Antiques, Art Guild

Max Yavno (1911–1985)
CABLE CAR, SAN FRANCISCO, 1947
Gelatin silver print
15¼ × 17⅜ in.
The Shirley Burden Fund for Photography

Brett Weston (1911–)
UNTITLED [Desert Landscape], 1947
Gelatin silver print
10¼ × 13½ in.
Gift of the artist

Minor White (1908–1976)
INSULATORS, NEWARK SUBSTATION, PG&E,
 1947
Gelatin silver print
11 × 14 in.
The Oakland Museum Founders Fund

Wynn Bullock (1902–1975)
CHILD IN THE FOREST, 1951
Gelatin silver print
14⅛ × 12 in.
Gift of Robert Toren

Pirkle Jones (1914–)
BREAKING WAVE, GOLDEN GATE, SAN
 FRANCISCO, 1952
Gelatin silver print
9¼ × 13¼ in.
Gift of Joseph M. Bransten

Dorothea Lange (1895–1965)
TRACT LIVING, NEAR MILPITAS, 1954/1988
Gelatin silver print
11 × 14 in.
The Dorothea Lange Collection, gift of
 Paul Schuster Taylor

Robert Frank (1924–)
SAN FRANCISCO, 1956/1977
From *The Americans*, 1959
Gelatin silver print
14 × 11 in.
The Shirley Burden Fund for Photography

Dorothea Lange (1895–1965)
U.S. HIGHWAY 40, 1956
Gelatin silver print
11 × 14 in.
The Dorothea Lange Collection, gift of
 Paul Schuster Taylor

Ansel Adams (1902–1984)
LONE PINE PEAK, THE SIERRA NEVADA
 MOUNTAINS, CALIFORNIA, c. 1960
From *Portfolio V*, 1970
Gelatin silver print
9¾ × 19¼ in.
The Oakland Museum Founders Fund

Garry Winogrand (1928–1984)
UNTITLED [Woman and Waiter], 1964
From the *New California Views* portfolio,
 1979
Gelatin silver print
16 × 20 in.
Museum Donors Acquisition Fund

Diane Arbus (1923–1971)
BISHOP BY THE SEA, LOS ANGELES, 1964
Gelatin silver print
11 × 14 in.
The Shirley Burden Fund for Photography

Helen Nestor (1924–)
THE FREE SPEECH MOVEMENT SIT-IN,
 1964/1988
Gelatin silver print
16 × 20 in.
The Shirley Burden Fund for Photography

Shirley C. Burden (1908–1989)
SWING, 1965
Dye coupler print
16 × 20 in.
Prints and Photographs Purchase Fund

Jonathan Eubanks (1927–)
BOATS ON THE LAKE, 1966
Gelatin silver print
15⅜ × 18½ in.
Museum Donors Acquisition Fund

Wynn Bullock (1902–1975)
OCEAN ROCKS, 1966
Gelatin silver print
9½ × 13¼ in.
The Oakland Museum Founders Fund

Edward Ruscha (1937–)
THIRTYFOUR PARKING LOTS IN LOS
 ANGELES, 1967
Pershing Square, underground lot, 5th and
 Hill, photographed by Art Alanis
10 × 8½ in.
Prints and Photographs Purchase Fund

William Garnett (1916–)
SAND DUNE, DEATH VALLEY, CALIFORNIA,
 1967
Cibachrome print
20½ × 24½ in.
Prints and Photographs Purchase Fund

Don Worth (1924–)
ROCKS AND SURF, SAN FRANCISCO, 1969
From the *Visual Dialogue Foundation,
 Founders Portfolio*, 1970
Gelatin silver print
11¾ × 9½ in.
Anonymous gift with matching funds from
 the National Endowment for the Arts

Mark Citret (1949–)
LONG SHADOWS, 1971
Gelatin silver print
8½ × 11¾ in.
Gift of the artist

Jack Fulton (1939–)
CALIFORNIA FUNK, 1971/1975
Cibachrome print
23¾ × 16 in.
Gift of the artist

*National Aeronautics and Space
 Administration* (established 1958)
CALIFORNIA FROM 570 MILES UP, 1972/1988
Chromogenic print from computer-assisted
 montage of 42 radio-transmitted signals
24 × 20 in.
Gift of Earth Observation Satellite
 Company

Steve Fitch (1949–)
UNTITLED [Wigwam Motel], 1973
Toned print
11½ × 14½ in.
Gift of the artist

Bea Ullrich-Zuckerman (1907–1987)
WARNING DANGEROUS, 1973
Gelatin silver print
13½ × 10½ in.
The Shirley Burden Fund for Photography

Victor Landweber (1943–)
HAND SERIES, NO. 1, 1973
Gelatin silver print
9¼ × 13½ in.
Gift of the artist

Lewis Baltz (1945–)
EAST WALL, WESTERN CARPET MILLS, 1231
 WARNER, TUSTIN, 1974
From *The New Industrial Parks Near Irvine,
 California*, 1975
Gelatin silver print
8 × 10 in.
Anonymous gift with matching funds from
 the National Endowment for the Arts

William Eggleston (1939–)
UNTITLED [Yellow Flowers], 1974/1980
Dye transfer print
16 × 19½ in.
Anonymous gift with matching funds from
 the National Endowment for the Arts

Ted Orland (1941–)
INSPIRATION POINT, YOSEMITE, 1975
Gelatin silver print, hand-tinted
11 × 13⅞ in.
Gift of Dr. and Mrs. Paul Wilhelm

Joseph Holmes (1952–)
CLOUDS OVER MONO LAKE, 1975/1981
Gelatin silver print
16 × 20 in.
The Shirley Burden Fund for Photography

Roger Minick (1944–)
FREEWAY INTERCHANGE, 1976
From the *Southland* series
Gelatin silver print, sepia-selenium toned
10¾ × 13¾ in.
Gift of the artist

Edmund Teske (1911–)
MONO LAKE, 1977
Duo-toned solarized print
18½ × 11½ in.
Gift of David Devine

Joe Deal (1947–)
SAN FERNANDO, CALIFORNIA, 1978
From the *Beach Cities* series
Gelatin silver print, gold-toned
13¾ × 13¾ in.
The Shirley Burden Fund for Photography

John Divola (1949–)
UNTITLED [Painted Interior], 1978
From the *Zuma* series
From the *New California Views* portfolio,
 1979
Cibachrome print
11 × 14 in.
Museum Donors Acquisition Fund

Kenneth McGowan (1940–1986)
PINK PANTHERS, 1978
From the *New California Views* portfolio,
 1979
Cibachrome print
11 × 14⅛ in.
Museum Donors Acquisition Fund

Jerry McMillan (1936–)
CALIFORNIA, 1978
Sulfide duo-toned print from a black-and-
 white photographic print
19⅞ × 16 in.
Prints and Photographs Purchase Fund

Richard Misrach (1949–)
UNTITLED [Desert Plant], 1979
From the *New California Views* portfolio,
 1979
Dye coupler print
10½ × 10½ in.
Gift of Dr. and Mrs. William Fielder

Iain Baxter (1936–)
REFLECTED SAN FRANCISCO BEAUTY
 SPOT — BUDDHA, GOLDEN GATE PARK,
 1979
Photographic transfer etching
34 × 29½ in.
Gift of World Savings and Loan
 Association

Arthur Ollman (1947–)
UNTITLED [Golden Gate Bridge], 1979
From the *New California Views* portfolio,
 1979
Dye coupler print
11 × 14 in.
Museum Donors Acquisition Fund

Anthony Hernandez (1947–)
PUBLIC FISHING AREAS, NO. 1, HERBERT C.
 LEGG LAKE, 1979
Gelatin silver print
12¾ × 18⅜ in.
Gift of the Art Docents in honor of
 George Neubert with matching funds
 from the National Endowment for
 the Arts

Stephen Shore (1947–)
MERCED RIVER, YOSEMITE NATIONAL PARK,
 1979
Dye coupler print
14 × 19 in.
Anonymous gift with matching funds from
 the National Endowment for the Arts

Michael Kenna (1953–)
REFLECTION, BIG SUR, CALIFORNIA, U.S.A.,
 1979/1980
Gelatin silver print, sepia-selenium toned
16 × 20 in.
Prints and Photographs Purchase Fund

Robbert Flick (1939–)
OCEAN I, SUMMER, 1980
From the *Sequential Views* series
Gelatin silver print
20 × 23¾ in.
Anonymous gift with matching funds from
 the National Endowment for the Arts

Roger Minick (1944–)
YOSEMITE NATIONAL PARK, 1980
From the *Sightseer* series
Dye coupler print
16 × 20 in.
Prints and Photographs Purchase Fund

John Gossage (1946–)
WEST L.A., 1980
Gelatin silver print
19 × 16 in.
Anonymous gift with matching funds from
 the National Endowment for the Arts

Judy Dater (1941–)
MY HANDS, DEATH VALLEY, 1980
From the *Self-Portraits* series
Gelatin silver print
16 × 20 in.
The Shirley Burden Fund for Photography

Terry Husebye (1945–)
UNTITLED [California Desert], 1980/1988
From the *Ocotillo Flat* series
Dye coupler print
24 × 20 in.
The Shirley Burden Fund for Photography

David Graham (1952–)
MOTHER AND DAUGHTER, NORTH OF SAN
 FRANCISCO, 1981
Dye coupler print
16 × 20 in.
The Shirley Burden Fund for Photography

Catherine Wagner (1953–)
NORTHWESTERN CORNER WITH SAWHORSE
 AND CEMENT MIXER, GEORGE MOSCONE
 SITE, SAN FRANCISCO, 1981
From the *Moscone* portfolio, 1981
Gelatin silver print
13½ × 18 in.
Anonymous gift with matching funds from
 the National Endowment for the Arts

147

Arthur Evans (1934–)
BARSTOW BAR, 1981
Dye coupler print
11 × 14 in.
Gift of the artist

Bill Dane (1938–)
ORANGE COUNTY, L.A. EVENT AND FAIR,
 1982
Gelatin silver print
16 × 20 in.
The Shirley Burden Fund for Photography

Brian D. Taylor (1954–)
THE ROAD TO SAN ANDREAS, 1982
Collage, gelatin silver print, hand-painted
16¼ × 21½ in.
Anonymous gift with matching funds from
 the National Endowment for the Arts

Sandra Haber (1956–)
PORTRAIT OF BRYNA, 1982
Dye coupler print
11½ × 28½ in.
Gift of the artist

David Hockney (1949–)
TELEPHONE POLE, LOS ANGELES,
 SEPTEMBER 1982, NO. 7, 1982
Instamatic color photographs mounted on
 silk-screened board
67 × 40½ in.
The Shirley Burden Fund for Photography
 and Dinkelspiel Fund

Richard Misrach (1949–)
WAITING, EDWARDS AIR FORCE BASE, 1983
Dye coupler print
26¾ × 33¾ in.
The Shirley Burden Fund for Photography

Morley Baer (1916–)
VINEYARD, ASTI, 1983
Cibachrome print
20 × 16 in.
Gift of the artist

Douglas Muir (1940–)
LANDSCAPING, SHERATON GRANDE HOTEL,
 LOS ANGELES, 1983
Dye coupler print
16 × 20 in.
Gift of the artist

Patrick Nagatani (1945–) and
 Andrée Tracey (1948–)
ATOMIC CAFE, 1983
Polaroid print
20 × 24 in.
Gift of the Collectors Gallery, Oakland
 Museum

Jeffrey Gates (1949–)
IN OUR PATH, NO. 4, 1983/1985
From the 20/20 portfolio, 1985
Gelatin silver print
15 × 19 in.
The Shirley Burden Fund for Photography
"The series In Our Path, of which this photo-
graph is a part, is about an area of Los
Angeles that was supposed to become a
freeway. Due to a court injunction filed by
homeowners, the Sierra Club, and the
NAACP, construction was delayed for nearly
a decade. The effect of this action resulted
in an abandoned and desolate strip of sub-
urbia dividing neighbors and communities.
This image is an example of how the
freeway will divide neighborhoods."
— Jeffrey Gates

Robert Adams (1937–)
DEAD PALMS, PARTIALLY UPROOTED,
 ONTARIO, CALIFORNIA, 1983/1988
Gelatin silver print
11 × 14 in.
The Shirley Burden Fund for Photography

Laurie Brown (1937–)
JOURNEY FORETOLD, LAGUNA NIGUEL,
 CALIFORNIA, 1984
From the Land-Site Displacement series
From the Earth Edges portfolio, 1984
Cibachrome print
13 × 30 in.
The Shirley Burden Fund for Photography

Robert Dawson (1950–)
SAN LUIS DRAIN, KESTERSON NATIONAL
 WILDLIFE REFUGE, 1985
From The Great Central Valley Project
Gelatin silver print
16 × 20 in.
The Shirley Burden Fund for Photography

Henry Wessel (1942–)
SOUTHERN CALIFORNIA, 1985/1988
Gelatin silver print
14 × 17 in.
The Shirley Burden Fund for Photography

Kenda North (1951–)
PURPLE FLOWERS, 1986
From the Marks on the Landscape series
Dye transfer print
16 × 20 in.
The Shirley Burden Fund for Photography

Lawrie Brown (1949–)
CALIFORNIA, 1986
Polaroid print
24 × 20 in.
The Shirley Burden Fund for Photography

John Baldessari (1931–)
TWO FIGURES/ONE WITH SHADOW, 1986
Photolithograph
20¼ × 19¾ in.
The Shirley Burden Fund for Photography

John Divola (1949–)
WOLF, 1983/1987
From the Five Prints portfolio, 1987
Dye transfer print
19¾ × 18¾ in.
The Shirley Burden Fund for Photography

Peter Goin (1951–)
IMPENETRABLE BORDER FENCE
 CONSTRUCTED BETWEEN CALEXICO AND
 MEXICALI AND TOPPED WITH BARBED
 CONCERTINA WIRE. THE METAL
 SECTIONS ARE USED TO REPAIR HOLES;
 CALLED THE "TORTILLA CURTAIN," 1987
From Tracing the Line: Survey of the Mexican-
 American Border, 1987
Gelatin silver print
11 × 14 in.
The Shirley Burden Fund for Photography

Nikolay Žurek (1936–)
WIND FARM, 1987
Dye transfer print
20 × 16 in.
The Shirley Burden Fund for Photography

Index of Artists

PICTURING CALIFORNIA

was designed by *Howard Jacobsen*

at *Triad,* San Rafael, California.

The type was set by *TBD Typography,* San Rafael.

The text face is Cloister,

with Cloister Open Face and Cochin Italic display.